*"Fellow-citizens, we cannot
escape history....
The fiery trial through
which we pass, will light us
down, in honor or dishonor,
to the latest generation....
In giving freedom to the
slave, we assure freedom to
the free—honorable alike
in what we give, and what
we preserve. We shall nobly
save, or meanly lose,
the last best, hope of earth."*

Abraham Lincoln
December 1, 1862

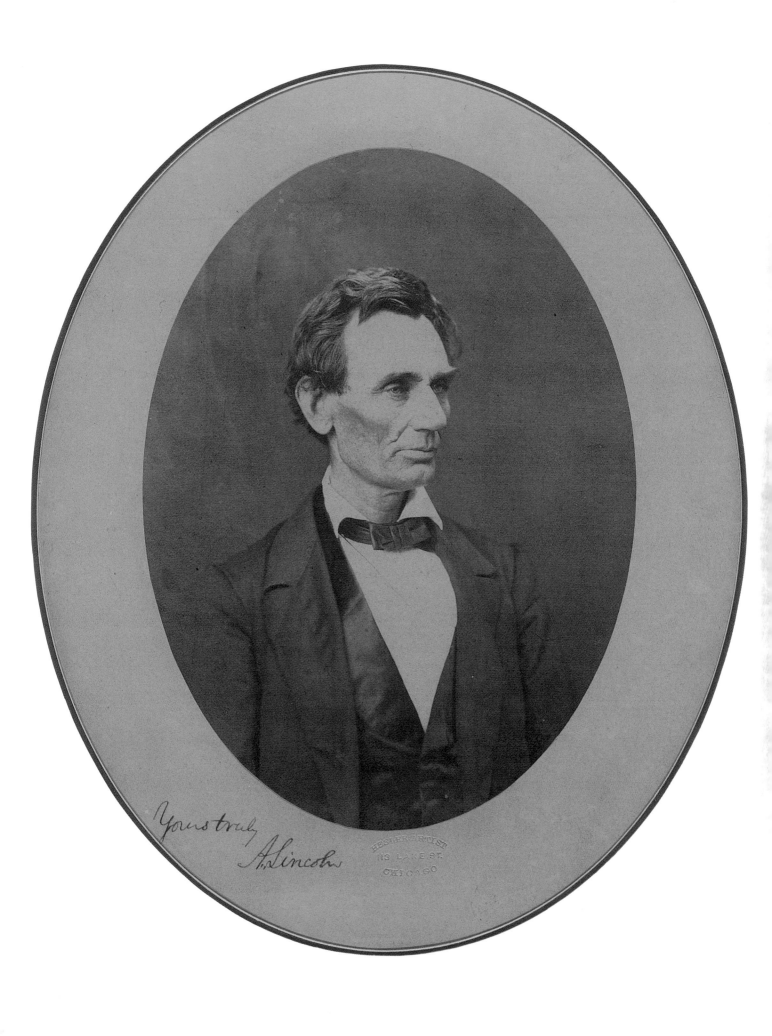

*Yours truly,*
*A. Lincoln*

HESLER, ARTIST
113 LAKE ST.
CHICAGO

# THE LAST BEST HOPE OF EARTH:

## ABRAHAM LINCOLN

### AND

## THE PROMISE OF AMERICA

*By*

JOHN H. RHODEHAMEL

*and*

THOMAS F. SCHWARTZ

*with a foreword by*

JAMES M. MCPHERSON

*Catalogue of an Exhibition at
the Huntington Library
October 1993 to August 1994*

HUNTINGTON LIBRARY
*San Marino, California*

## A Note on Contributors

Sections I, II, III, and VI, were written by Thomas F. Schwartz, curator of the Henry Horner Lincoln Collection at the Illinois State Historical Library, Springfield, Illinois. Sections IV, V, VII, and VIII were written by John Rhodehamel, curator of American history at the Huntington Library. Pulitzer Prize-winning historian James M. McPherson is George Henry Davis professor of American history at Princeton University.

Photography by Robert Schlosser and John Sullivan of the Huntington Library.

The publication of this catalogue is made possible by the generous support of Nestlé USA.

Henry E. Huntington Library and Art Gallery, 1151 Oxford Road, San Marino, California 91108.
© Copyright 1993 by the Henry E. Huntington Library and Art Gallery. All rights reserved. Printed in the United States of America.

Library of Congress Cataloging-in-Publication Data

Rhodehamel, John H.
    The last best hope of earth : Abraham Lincoln and the promise of America : catalogue of an exhibition at the Huntington Library, October 1993-August 1994 / by John Rhodehamel and Thomas F. Schwartz, with a foreword by James M. McPherson.
        p.    cm.
    Includes bibliographical references (p.).
    ISBN 0-87328-142-X (pbk.)
    1. Lincoln, Abraham. 1809-1865–Exhibitions. 2. Presidents–United States–Biography–Exhibitions. 3. United States–History–Civil War, 1861-1865–Exhibitions.
    I. Schwartz, Thomas F. II. Henry E. Huntington Library and Art Gallery. III. Title.
E453.R49    1993
973.7′092–dc20        93-11401

# Contents

# Foreword

On December 1, 1862, Abraham Lincoln delivered his second Annual Message to Congress. Today we would call it the State of the Union Address. The state of the Union at the end of 1862 was perilous—the Confederate States of America stood proud and defiant as an independent nation whose existence flouted the pretense of Union. Northern armies were experiencing frustration and defeat on all fronts. Political opposition in Washington menaced the Lincoln administration's ability to carry on the war to restore the Union. That opposition focused particularly on the Emancipation Proclamation, announced the previous September and scheduled to go into effect on January 1, 1863. Lincoln had embraced emancipation both as a way to weaken the Confederate war effort by depriving it of slave labor and as a sweeping expansion of Union war aims. No longer would the North fight merely for restoration of the old Union—a Union with slavery to mock American ideals of liberty. Now it would fight to give that Union "a new birth of freedom," as Lincoln put it almost a year later at Gettysburg.

By then the prospects of Northern victory appeared much brighter than they did in December 1862. Nevertheless, Lincoln's eloquence at this dark time shone through as brightly as it did at Gettysburg. "Fellow-citizens, *we* cannot escape history," he told Congress and through them, the American people, in an appeal for support of his emancipation policy. "The fiery trial through which we pass, will light us down, in honor or dishonor, to the *latest* generation....We know how to save the Union....In *giving* freedom to the *slave*, we *assure* freedom to the *free*—honorable alike in what we give, and what we preserve. We shall nobly save, or meanly lose, the last best, hope of earth."

What did Lincoln mean? Why did he consider the Union—by which he meant the United States as one nation indivisible—to be the last best hope of earth? The last best hope for what? The answers lie in the letters, speeches, and other documents that are part of this exhibit—one of the largest and richest collections of Lincoln's writings ever gathered for public display. The central vision that guided Lincoln through the trauma of sectional conflict was the preservation of the United States as a republic governed by popular suffrage, majority rule, and the Constitution. If the Confederate States succeeded in their effort to sever the United States in twain, they would destroy the whole idea of a republican government. The next time a disaffected minority lost a presidential election, as Southern-Rights Democrats had lost in 1860, that minority might invoke the Confederate precedent to proclaim secession. The United States would fragment into a dozen squabbling autocracies, the laughing stock of the world. Monarchists and aristocrats and reactionaries in Europe would be proved right in their contention that this upstart republic launched in 1776 would come crashing down. The hopes of liberals and the oppressed everywhere for the success of the American experiment in democracy would be smashed. "The central idea pervading this struggle," Lincoln told his private secretary early in the war, "is the necessity that is upon us, of proving that popular government is not

an absurdity. We must settle this question now, whether in a free government the minority have the right to break up the government whenever they choose. If we fail it will go far to prove the incapability of the people to govern themselves."

Lincoln believed the Civil War to be a critical turning point in history. The trend in western societies during the nineteenth century was toward greater rights and opportunity for the common people. But that trend could be turned back toward despotism, as it had been after the short-lived revolutions of 1848 in Europe. If the United States suffered a similar relapse, the dark night of tyranny might return. That was why, Lincoln said, "this is essentially a People's contest...a struggle for maintaining in the world, that form, and substance of government, whose leading object is, to elevate the condition of men—to lift artificial weights from all shoulders...to afford all, an unfettered start, and a fair chance in the race of life." Nor was this struggle "altogether for today—it is for a vast future also." It "embraces more than the fate of these United States. It presents to the whole family of man the question whether," as

Lincoln expressed it in the Gettysburg Address, a nation "conceived in Liberty, and dedicated to the proposition that all men are created equal...shall not perish from the earth."

Slavery had always been the canker in this republican ideal, the "monstrous injustice," as Lincoln put it in 1854, that "deprives our republican example of its just influence in the world—enables the enemies of free institutions, with plausibility, to taunt us as hypocrites." The story of how slavery drove a wedge in the Union and of how, under Lincoln's guiding hand, the war for the Union became a war for a new birth of freedom, is beautifully told in this exhibit. The viewer will come away with a new birth of understanding of how, in giving freedom to the slave, Lincoln nobly saved the last best hope of earth.

James M. McPherson
*George Henry Davis Professor of American History at Princeton University*

# Introduction

In mounting what is arguably the largest and most comprehensive exhibit of original Lincoln materials ever, the Library provokes thoughtful contemplation of the Lincoln legacy, especially his vision of America as a land of opportunity and a government based on democratic ideals. His experience, and his message, speak directly to our own time. Although the great American experiment survived the tests of Civil War and the assassination of our sixteenth president, succeeding generations have had to contend with new threats to freedom, and even today the fundamental goal of social justice remains elusive. We still wrestle with the consequences of slavery; we are still called upon to rededicate ourselves to the "unfinished work" of those who fell at Gettysburg; we are still called upon to work for a "new birth of freedom." Lincoln's words still resonate.

The exhibit represents an unprecedented collaboration between the Huntington Library and the Illinois State Historical Library, and draws as well upon the extensive private collection of Lincolniana amassed by Louise and Barry Taper. It is co-curated by Thomas F. Schwartz, curator of the Illinois State Historical Library's Henry Horner Lincoln Collection, and John Rhodehamel, curator of American history at the Huntington; and they have been advised by James M. McPherson, the Henry George Davis professor of history at Princeton University, who has served as our chief scholarly consultant.

The entire undertaking, which includes an extensive educational program for area young people and a major scholarly symposium, was made possible by a generous grant from the National Endowment for the Humanities, with additional support from Nestlé USA which assured the publication of this catalog, and from Bank of America, ARCO Foundation, The William and Flora Hewlett Foundation, The Seaver Institute, Union Bank of Switzerland, and the H. Russell Smith Foundation. We are grateful for their support, and to Harvard University Press for co-publishing a superb companion biography of Lincoln by Pulitzer Prize-winning author, Mark Neely, Jr.

William A. Moffett
*Director of the Huntington Library*

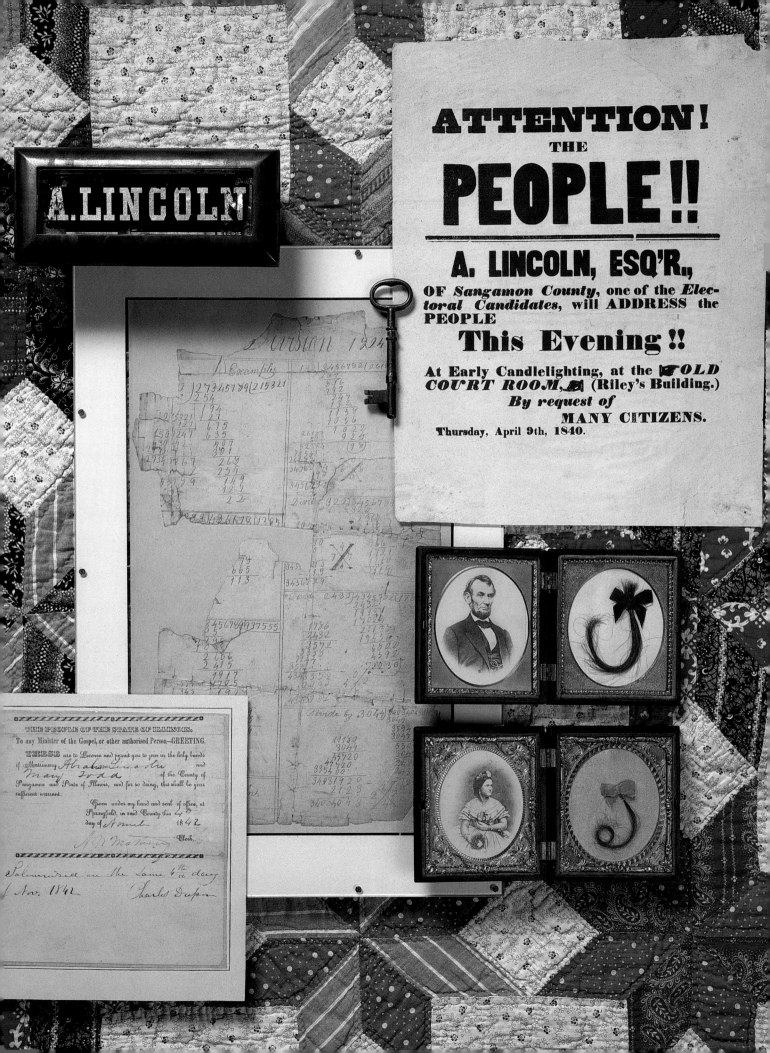

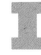

# Frontier Beginnings

*"A fair chance*
*in the race of life"*

More than any other American, Abraham Lincoln embodies the powerful elements that have come to stand for the American Dream. With less than a year of formal schooling, he was largely self-taught, and yet is revered worldwide for his elegant prose in explicating the strengths of self-government. His early endeavors as a store clerk, postmaster, captain of the state militia, surveyor, and lawyer were always characterized by wit, honesty, and ambition to succeed. He became one of Illinois' leading lawyers, earning himself a comfortable income that allowed him to pursue his true interest—politics. Even in political life, Lincoln accomplished what few others can claim: he went from a lowly birth in a log cabin to the presidency, the republic's highest elective office. Lincoln believed that "the legitimate object of government, is to do for a community of people, whatever they need to have done, but can not do, *at all*, or can not, *so well do*, for themselves—in their separate, and individual capacities." Lincoln's driving ambition to succeed stood witness to the right to rise in America as well as the importance of a system of government that made his success possible. It was the twin challenges of slavery and secession that threatened to undermine Lincoln's vision of America.

With an allusion to Gray's *Elegy*, Lincoln dismissed his childhood and his early life in Kentucky and Indiana as "the short and simple annals of the poor." The Lincolns left Kentucky for Indiana in 1816, in part because of their opposition to slavery, but mostly because his father, Thomas Lincoln, found it difficult to secure clear title to his land. Two years later Lincoln's mother died. Thomas Lincoln married an old sweetheart in 1819, providing Abraham and his sister Sarah with a step-mother, two stepsisters and a stepbrother. Lincoln's childhood was characterized not so much by poverty as by hard work. When the family moved to Illinois in 1830, Lincoln, having reached manhood, ventured off on his own after building his parents' homestead. A merchant named Denton Offutt offered the young Lincoln a job taking a flatboat down the Mississippi River to New Orleans. Offutt was impressed with Lincoln and offered him a job clerking in a store in New Salem, Illinois. The New Salem years gave definition to Lincoln's life. It was in this frontier boomtown that Lincoln dreamed of his future. He worked hard to win the admiration and trust of his fellow townspeople, to find a vocation, and to establish financial security.

## The Right to Rise

*"Every man has
his peculiar ambition"*

Lincoln's first bid for public office came in 1832, when he ran for the Illinois House of Representatives. His platform called for the improvement of navigation on the Sangamon River, changes in banking laws, and the establishment of universal education. Lincoln had been a resident of New Salem for only seven months prior to the election, but carried his local precinct by 277 votes to 7. When added to the total votes from the district, Lincoln lost. His attempt in 1834, however, was successful. He served four consecutive terms in the state legislature.

Lincoln's early political philosophy emphasized his "right to rise" beliefs. Lincoln belonged to the Whig party, one of the two major American political parties of the day. The Whigs favored internal improvements like roads and canals to link the goods and produce of the interior with urban markets. They called for a strong banking system to provide sound currency and emphasized the importance of public education as the basis for good citizenship and individual achievement. For many years, Abraham Lincoln believed that the Whig party and its programs offered Americans the best hope for improving their lives. In both Illinois and in the national government, however, the Whigs often found themselves in the role of loyal opposition to the more powerful Democratic party.

Lincoln's legal training comported well with his political ambitions. His early mentors were men who were both outstanding legal thinkers and leading political figures in central Illinois. The law offered Lincoln, who had moved from New Salem to Springfield in 1837, an opportunity to travel throughout Illinois, building a network of political associates while earning a living. He became an expert in the emerging field of corporate law, especially in cases that involved railroads. In 1846 Lincoln was elected to the United States Congress, serving one term in the House of Representatives. He tried without success to introduce a bill outlawing slavery in the District of Columbia and in 1848 was a vocal critic of President Polk's war policy against Mexico. Lincoln campaigned vigorously on behalf of the Whig presidential candidate Zachary Taylor in 1848. His efforts were rewarded by Taylor, who offered the Illinois lawyer the governorship of Oregon. But Lincoln felt that a territorial governorship would isolate him from friends and political events. Financial and family concerns turned Lincoln away from politics and back to his legal practice. From 1849 to 1854, Lincoln followed political developments with intense interest but found little reason to seek office.

## The Lincoln Family

*"In this troublesome
world, we are
never quite satisfied"*

On November 4, 1842, Abraham Lincoln married Mary Todd, a vivacious, wellborn Kentucky woman nine years his junior. Their relationship was one of love as well as ambition. Mary helped and encouraged her husband's political strivings. They brought four sons into the world—Robert, Edward, William and Thomas. Only the eldest, Robert Todd Lincoln (1843-1926), would live beyond his eighteenth birthday. Lincoln's law practice required him to travel the Eighth Judicial Circuit three months in the spring and three months in the fall. During an election year, Lincoln might be absent from home for even longer periods. Because of his absences, most of the child-rearing, as well as the burden of housekeeping, fell on Mary. She continued to expand the house as the family and her husband's finances grew. It was not difficult to keep up with the latest home-decorating trends since many Springfield stores could obtain goods from St. Louis. Abraham Lincoln earned a substantial living as a lawyer, and Mary used this income to provide a comfortable middle-class life for their family.

The Lincoln children were indulged by their parents. Friends and neighbors complained that Abraham failed to discipline them

for their bad behavior. Law partner William Herndon often found the law office turned upside down by Lincoln's sons. "I have felt many and many a time that I wanted to wring their little necks," wrote Herndon of the Lincoln boys, "and yet out of respect for Lincoln I kept my mouth shut." Mary read her children the classics and taught them social graces, even if the boys did not always practice them. The Lincolns placed great importance on their sons' education. Robert was sent to Harvard University. Abraham and Mary Lincoln worked tirelessly to create for their children a better life than they themselves had experienced.

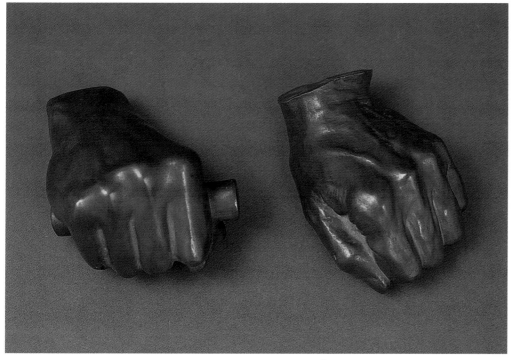

**Leonard Wells Volk, casts of Lincoln's hands in 1860, bronze.** (Taper Collection)

Abraham Lincoln's big hands were toughened by toil. People remembered the young Lincoln as one of the strongest men in the county. These casts of his hands were made in 1860.

**Abraham Lincoln, document filled out and signed, September 26, 1832. Illinois militia discharge, Black Hawk War.** (Huntington Library)

Abraham Lincoln's only firsthand military experience was his service in the Illinois militia in a minor Indian war in 1832. Lincoln was elected captain of his company, *"a success that gave me more pleasure than any I have had since,"* he recalled in 1859. Captain Lincoln saw no fighting and soon returned to civilian life. Yet during the Civil War the former militia soldier was commander in chief of the largest army and navy in the world.

I hereby certify that the annexed is a
correct map of the town of Huron; and
that the requisites of the statutes, in such
cases made and and provided, have been
complied with.

May 21. 1836.

A. Lincoln
for Thomas M. Neale
Surveyor of Sanga-
mon County.

Explanation
Width of Streets . . . . 70 feet
Do " Alleys . . . . 16 "
Depth of Lots . . . . 112 "
Front " . . . . 60 "
Stone at the S.W. corner of the
Public Square
Scale of the map 200 feet to the inch

Proposed Canal

SLOUGH

Canal Street

8    7    6    5    4    3    2    1

First Street

9    10    11    12    13    14    15    16

Second Street

24    23    22    21    20    19    18    17

Third Street

25    26    27    28    29    30    31    32

Fourth Street

40    39    38    37    36    35    34    33

Fifth Street

41    42    43    44    45    46    47    48

# MAP OF HURON.

Abraham Lincoln, autograph
document signed, May 21, 1836.
Town plat, survey of Huron, Illi-
nois. (Illinois State Historical Library)

Lincoln took up surveying as a possi-
ble career as well as a way to pay the
many creditors from his failed store.
Though most of his surveys were of
roads or individual pieces of property,
Lincoln also surveyed six towns.
Huron was one. But people did not
settle in Huron; the town existed only
on paper. Huron's history was typical
of the fluid democratic society in
which Abraham Lincoln came of age.

Wall clock from the Lincoln-
Herndon law office, Springfield,
Illinois. (Taper Collection)

The practice of law provided
Abraham Lincoln with a good income.
This handsome wall clock from the
law office of Lincoln and his partner
William Herndon reflected his
successful practice.

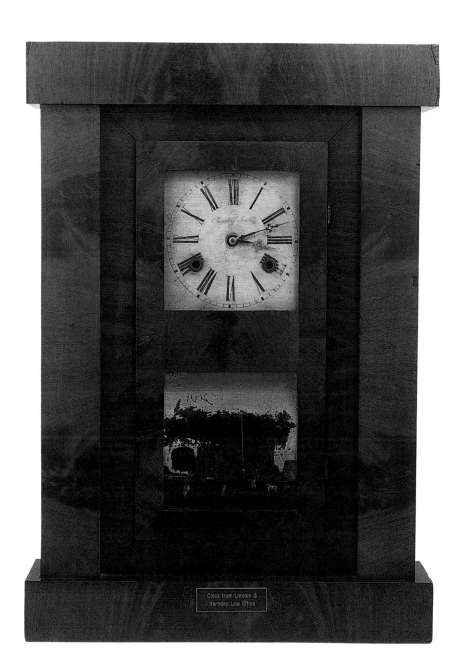

[Abraham Lincoln],
"To the Public," August 5, 1837.
(Taper Collection)

One of Lincoln's earliest legal cases concerned obtaining clear title to land belonging to a poor widow, Mary Anderson. Lincoln believed a respected probate judge, James Adams, had forged documents transferring the land to himself. By anonymously issuing this handbill among Springfield's citizens, Lincoln hoped to win public opinion over to Mary Anderson. His strategy failed and both Mary Anderson and James Adams died before the suit was resolved. This is the only known copy of the earliest Lincoln imprint.

[Abraham Lincoln], beaver pelt stovepipe hat. (Taper Collection)

Lincoln wore this hat during the Civil War. During his days as New Salem postmaster, Lincoln had gotten in the habit of storing letters and papers in his hat. Law partner William Herndon called Lincoln's stovepipe hat "an extraordinary receptacle [which] served as his desk and memorandum book."

## TO THE PUBLIC·

*[body text of handbill, largely illegible]*

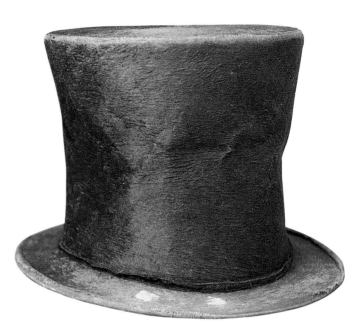

Abraham Lincoln, autograph letter signed to Mary Todd Lincoln, April 16, 1848.
(Illinois State Historical Library)

Mary and two small children, Bobby and Eddie, accompanied Congressman Abraham Lincoln to Washington. The rooming house where the Lincolns took lodging proved to be a poor place to raise a family. Mary and the children soon left to live with her father in Lexington, Kentucky. Lincoln became lonely without them. His poignant letter illustrates his feelings:

*"In this troublesome world, we are never quite satisfied. When you were here, I thought you hindered me some in attending to business; but now, having nothing but business—no variety—it has grown exceedingly tasteless to me."*

Washington, April 16- 1848-

Dear Mary:

In this troublesome world, we are never quite satisfied- When you were here, I thought you hindered me some in attending to business; but now, having nothing but business- no variety- it has grown exceedingly tasteless to me- I hate to sit down and direct documents, and I hate to stay in this old room by myself- You know I told you in last sundays letter, I was going to make a little speech during the week; but the week has passed away without my getting a chance to do so; and now, my interest in the subject has passed away too- Your second and third letters have been received since I wrote before. Dear Eddy thinks father is "gone tapila" Has any further discovery been made as to the breaking into your grand-mother's house?- If I were she, I would not remain there alone- You mention that your uncle John Parker is likely to be at Lexington- Dont forget to present him my very kindest regards-

I went yesterday to hunt the little plaid stockings, as you wished; but found that McKnight has quit business, and Allen had not a single pair of the description you give, and only one pair plain pair of any sort that I thought would fit "Eddy's dear little feet"- I have a notion to

19

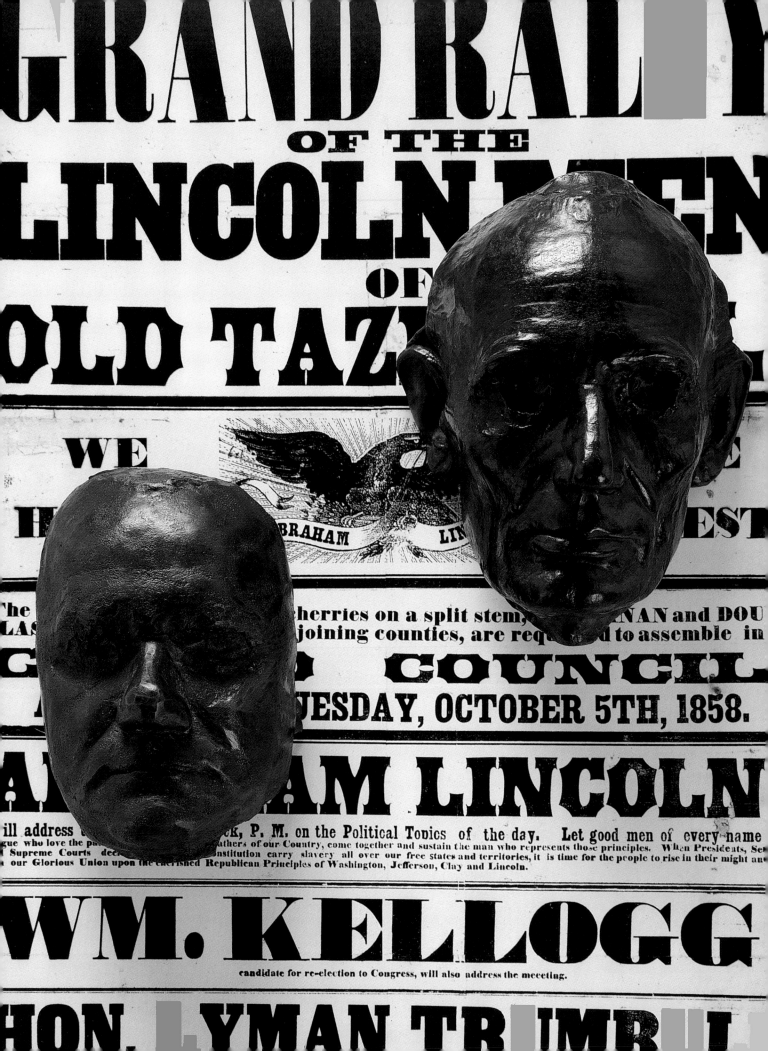

# Slavery in the Great Republic

## *"The monstrous injustice"*

Leonard Wells Volk, life mask in bronze of Abraham Lincoln, 1860. (Taper Collection)

Leonard Wells Volk, life mask in bronze of Stephen A. Douglas, c. 1856. (Taper Collection)

*Grand Rally of the Lincoln Men of Old Tazewell! We Honor the Honest Abraham Lincoln. At Pekin, on Tuesday, October 5th, 1858....* (Pekin, Illinois, 1858). Broadside from the 1858 Lincoln-Douglas Senate race. (Illinois State Historical Library)

This is the only known broadside publicizing the Lincoln-Douglas Senate contest of 1858. The poster trumpeted a rally of "Lincoln Men" in Tazewell County, one of the Republican candidate's strongest areas of support.

The arrival of the first African laborers to the English colony of Virginia in 1619 began the long and tragic history of slavery in North America. By 1776, when Americans fought a revolution against Britain for independence and "life, liberty, and the pursuit of happiness," slavery had already prevailed in their country for more than a century and a half. In the years that followed, the new nation flourished. Pacing the growth of the United States was the rise of American slavery. There were about 650,000 slaves in 1787, as many as four million in 1865. By the mid-nineteenth century, the territory of the slave states was greater than all the thirteen colonies in 1776. As the nation matured, the debate over slavery grew more heated. Nothing fueled the conflict as much as the country's westward expansion. Territorial expansion was a dynamic central to American nationhood, but each new state admitted to the Union threatened to upset the balance of political power between the slave and free states. A series of Congressional compromises over the admission of new states served to postpone a showdown.

Abraham Lincoln had always hated slavery. It was, he insisted, a "monstrous injustice...an unqualified evil to the negro, the white man, and the State....If slavery is not wrong, nothing is wrong. I cannot remember when I did not so think, and feel." Lincoln believed that the nation's founders had hated slavery too, and had looked forward to its eventual abolition. They had excluded slavery from the Northwest territory in 1787. The African slave trade had been outlawed after 1808. And in 1820, the Missouri Compromise

had banned slavery from the northern part of the Louisiana Purchase. Lincoln believed these restrictions had put slavery on the road to "ultimate extinction," even though the final end might not come for many years. Though he said it "crucified" his feelings, Lincoln was willing to accept the continued presence of slavery, rather than risk disunion and the ruin of the American experiment in self-government.

Throughout the first half of the nineteenth century, many Americans called for the end of slavery. But slaveowners became increasingly suspicious of any action that seemed to threaten Southern economic and social relationships. Several events in the 1850s heightened tensions between the proslavery and antislavery forces. The Kansas-Nebraska Act of 1854 in effect repealed the Missouri Compromise by giving the inhabitants of the western territories the right to decide the slavery question through popular elections. A vast new region was opened to the spread of slavery. Kansas became the battleground. Competing territorial governments and constitutions were organized in Kansas: one legalized slavery and the other outlawed it. Violence followed as both groups tried to assert their will. When Senator Charles Sumner of Massachusetts spoke against President Pierce's support of the slavery forces in Kansas, he was badly beaten on the floor of the Senate by South Carolina Congressman Preston Brooks. The Dred Scott decision seemed to many to be the final defeat in a series of setbacks for the containment of slavery. The Supreme Court, led by the proslavery Chief Justice Roger B. Taney, denied

that blacks met qualifications as citizens or held any rights under law; they remained mere property. As property, the court ruled, Congress could not exclude slavery from the territories since such action violated the due process

clause of the Constitution. The cumulative effect of the events of the 1850s was to destroy the Whig party and create a realignment of political forces behind an antislavery Republican ideology.

## Back in the Political Arena

*"The Union, forever worthy of the saving"*

The passage of the Kansas-Nebraska Act in 1854 propelled Abraham Lincoln back into the political fray. Like many moderates, Lincoln saw the Kansas-Nebraska Act as transforming the debate on slavery. Not only was he concerned that it reopened territories previously closed to slavery but he increasingly recognized that slavery was incompatible with a free society. The moral dimensions of slavery became the focus of Lincoln's thought and writing. He said of the Kansas-Nebraska Act that "I particularly object to the new position which the avowed principle of this Nebraska law gives to slavery in the body politic. I object to it because it assumes that there can be moral right in the enslaving of one man to another."

In 1854, Lincoln found himself in a three-way race for the U.S. Senate against the antislavery Democrat Lyman Trumbull and the wily Democratic governor, Joel Matteson. When a Matteson victory became a possibility, Lincoln threw his support behind Trumbull, assuring his election. In 1856 Lincoln joined ranks with the new Republican party in Illinois and worked to build it into a viable organization. His main task was to attract dissatisfied Democrats, former Whigs, and voters from the American Party, also called the Know-Nothing Party. With amazing success, Lincoln and the Illinois Republicans were able to elect a Republican governor and an entire slate of Republican state officials.

## The Lincoln-Douglas Debates

*"The great fundamental principle"*

On July 24, 1858, Lincoln sent the following note to Senator Stephen A. Douglas, "Will it be agreeable to you to make an arrangement for you and myself to divide time, and address the same audiences during the present canvass?" Thus began negotiations resulting in the famous Lincoln-Douglas debates. Douglas agreed to seven debates in seven Illinois towns in the three months before the November election. Douglas's national prominence and his public feud with Democratic President James Buchanan over a proslavery Kansas constitution guaranteed press coverage and large crowds. Lincoln was still largely unknown outside Illinois. A strong showing against Douglas could advance Lincoln's career and strengthen the Illinois Republican party.

Throughout the debates, Douglas defended his support for the Kansas-Nebraska Act and his doctrine of popular sovereignty to deal with the question of slavery in the territories. He had no qualms about the perpetual

existence of slavery and tried to paint Lincoln as a dangerous radical who sought to disrupt sectional harmony by attacking slavery. Lincoln countered by arguing that slavery was a great moral evil which intensified sectional unrest. The Kansas-Nebraska Act removed the barrier set by the Missouri Compromise, permitting the contagion of slavery to spread into the territories. The federal government, Lincoln argued, had no power to interfere with slavery in the states where it already existed. But the government did have the right to keep slavery out of the territories. Once contained, Lincoln felt it would eventually collapse under the weight of its internal contradictions. Thus the main point of contention was whether slavery should be viewed as a moral evil.

Douglas won the election, but at the price of placing Lincoln prominently before a national audience.

*The Anti-Slavery Alphabet,*
(Philadelphia: Printed for the
Anti-Slavery Fair, 1847).
(Huntington Library)

Growing antislavery sentiment in the
North was revealed in many ways.
This little hand-colored book taught

children their ABC's and the evils of
slavery at the same time. "A" is for
"Abolitionist"– the opponents of slav-
ery who said plainly that slavery was
evil. But many Southerners continued
to defend slavery as a "positive good"
for both races.

Abraham Lincoln, autograph
document, "Pro-slavery theology"
[October 1, 1858?].
(Illinois State Historical Library)

In this private meditation on slavery,
Lincoln demolished the "pro-slavery
theology" of Frederick Ross, author of
*Slavery Ordained of God.* Rev. Ross
had concluded that God favored
slavery. But Lincoln believed that self-
interest, not religion, had shaped
Ross's thinking:

*"Dr. Ross....sits in the shade, with
gloves on his hands, and subsists on the
bread that Sambo is earning in the
burning sun. If he decides that God
Wills Sambo to continue a slave, he
thereby retains his own comfortable
position; but if he decides that God
will's Sambo to be free, he thereby has
to walk out of the shade, throw off his
gloves, and delve for his own bread."*

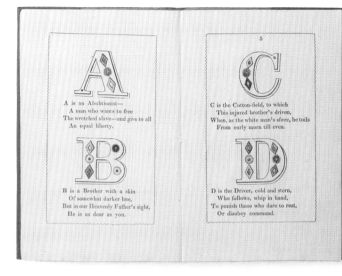

SLAVERY

ORDAINED OF GOD.

"The powers that be are ordained of God."
ROMANS XIII. 1.

BY

REV. FRED. A. ROSS, D.D.

PASTOR OF THE PRESBYTERIAN CHURCH, HUNTSVILLE, ALABAMA.

PHILADELPHIA:
J. B. LIPPINCOTT & CO.
1857.

Frederick A. Ross, *Slavery
Ordained of God* (Philadelphia, 1857).
(Huntington Library)

Frederick Ross, an Alabama clergy-
man, used the Bible to "prove" that
God wanted white Americans to
enslave black Americans. Ross's
assumptions were typical of the way
Southern whites defended the insti-
tution on which their society was
founded. Abraham Lincoln thought
that arguments of slaveowners in favor
of slavery were flawed and self-
serving. Lincoln made his case in the
undated manuscript he titled *"Pro-
slavery theology."*

Abraham Lincoln, autograph letter signed to Jonathan Y. Scammon, November 10, 1854.
(Illinois State Historical Library)

The passage of Stephen A. Douglas's Kansas-Nebraska Act in 1854 propelled Lincoln back into the political arena. The law opened a vast new region to the spread of slavery by giving the people of the western territories the power to accept or reject slavery. Lincoln believed the future of American democracy was at stake. He decided to run for the U.S. Senate. In this letter he observed that:

*"Some partial friends here are for me for the U.S. Senate; and it would be very foolish, and very false, for me to deny that I would be pleased with an election to that Honorable body."*

opposite: Abraham Lincoln, autograph letter signed to Owen Lovejoy, August 11, 1855.
(Huntington Library)

The great changes in American politics in the 1850s brought about the death of Lincoln's Whig party and the birth of a new antislavery party—the Republicans. In this letter to a well-known abolitionist, Lincoln declared his willingness to *"stand with any body who stands right"*—that is anyone who opposed the spread of slavery into new territories. Lincoln joined the Republican party in 1856.

Abraham Lincoln, autograph document [1 August 1858?].
(Illinois State Historical Library)

One of Lincoln's most concise statements on slavery is his definition of democracy:

*"As I would not be a slave, so I would not be a master. This expresses my idea of democracy. Whatever differs from this, to the extent of the difference, is no democracy."*

Springfield, August 11- 1855

Hon: Owen Lovejoy:

My dear Sir:

Yours of the 7th was received the day before yesterday- Not even you are more anxious to prevent the extension of slavery than I, and yet the political atmosphere is such, just now, that I fear to do any thing, lest I do wrong- Know-nothingism has not yet entirely tumbled to pieces- Nay, it is even a little encouraged by the late elections in Tennessee, Kentucky, & Alabama- Until we can get the elements of this organization, there is not sufficient materials to successfully combat the Nebraska democracy with- We can not get them so long as they cling to a hope of success under their own organization; and I fear an open push by us now, may offend them, and tend to prevent our ever getting them. About us here, they are mostly my old political and personal friends; and I have hoped their organization would die out without the painful necessity of my taking an open stand against them- Of their principles I think little better than I do of those of the slavery extensionists- Indeed I do not perceive how any one

Abraham Lincoln, autograph letter signed to James N. Brown, October 18,1858, written in a notebook containing "the substance of all I have ever said about 'negro equality.' " (Huntington Library)

Hoping to brand Lincoln a radical, Stephen Douglas had charged that his opponent favored complete racial equality. No Illinois politician could have won election on such a platform in 1858. Lincoln denied that he advocated equality, but went on to affirm that

*"I think the negro is included in the word 'men' used in the Declaration of Independence. I believe the declaration that 'all men are created equal' is the great fundamental principle upon which our free institutions rest."*

*"A house divided against itself cannot stand,"* Abraham Lincoln had said in his famous speech he made at the time of his nomination for the U.S. Senate in June 1858. Lincoln said he wanted to put slavery on a *"course of ultimate extinction."* Some thought Lincoln was calling for all-out war against slavery. But in this letter, Lincoln denied he wanted to attack slavery where it already existed. What he did oppose was *"the effort to spread slavery into the new teritories."*

Springfield, June 23. 1858

Jno. L. Scripps, Esq,
   My dear Sir

      Your kind note of yesterday
is duly received— I am much flattered by the
estimate you place on my late speech; and yet
I am much mortified that any part of it should
be construed so differently from any thing intended
by me— The language "place it where the public
mind shall rest in the belief that it is in course
of ultimate extinction" I used deliberately, not
dreaming then, nor believing now, that it asserts,
or intimates, any power or purpose, to interfere with
slavery in the States where it exists— But, to not
cavil about language, I declare that whether the clause
used by me, will bear such construction or not,
I never so intended it. I have declared a
thousand times, and now repeat that, in my opinion
neither the
General Government, nor any other power outside of
the slave states, can Constitutionally or rightfully
interfere with slaves or slavery where it already
exists— I believe that whenever the effort to
spread slavery into the new territories, by whatever
means, and into the free states themselves, by Su-
preme Court decision, shall be fairly headed
off, the institution will then be in course of
ultimate extinction; and by the language

27

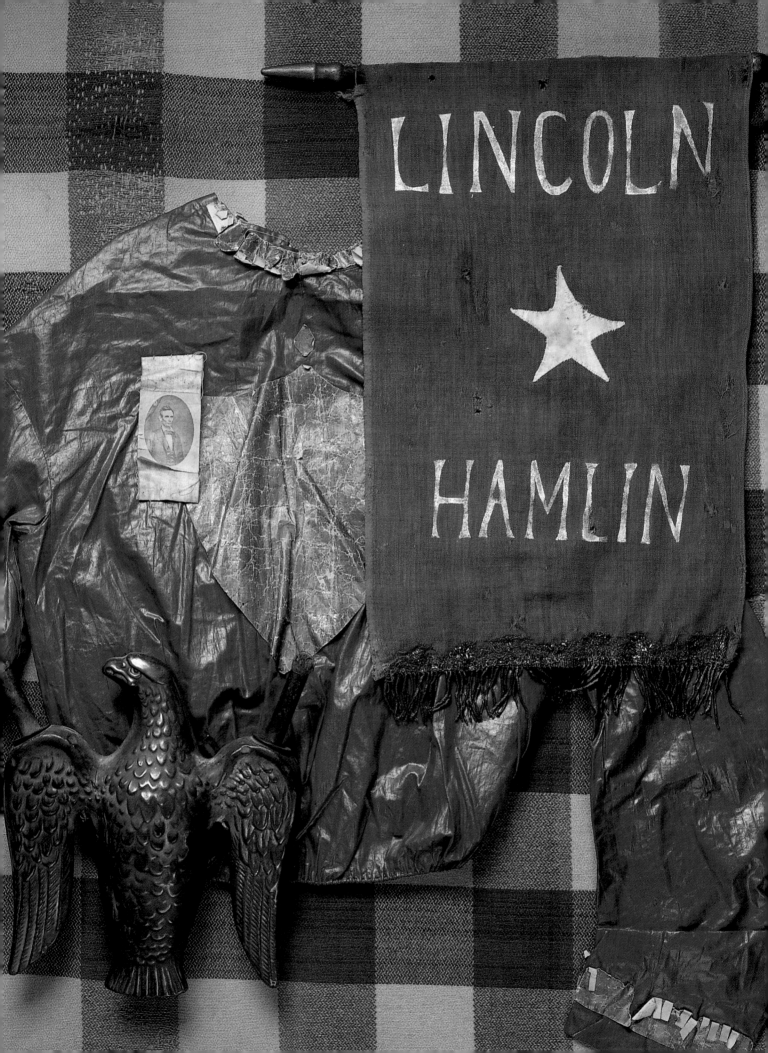

# Nominated
# for the Presidency

*"The taste is
in my mouth"*

The national prominence of the Lincoln-Douglas contest brought Lincoln requests for appearances from Republicans throughout the country. Lincoln, however, declined most requests, explaining in 1859 that "this year I must devote to my private business." He made an exception when Ohio Republican leaders asked him to counter Douglas's attempts to sway upcoming elections for the Democrats. Lincoln spoke at Columbus, Dayton, and Cincinnati, essentially continuing the debate with Douglas begun the previous year. It is difficult to know to what extent Lincoln's efforts contributed to the Republican election victory, but his aid to the cause was acknowledged. Speaking engagements increased as Lincoln appeared at Indianapolis, Milwaukee, Beloit, and Janesville; in December he conducted a tour of Kansas. Lincoln drafted an autobiographical sketch, finalized arrangements for publication of his debates with Douglas, and began working on his Cooper Union address for his New York City debut in 1860. More and more, the Illinoisan was acting like a presidential candidate.

Two factors weighed most heavily in Lincoln's favor. After John Brown's abortive attempt to touch off a slave rebellion with his 1859 raid on Harpers Ferry, many moderate Republicans feared that their party would be tied to Brown's extremism. They recognized the need to run a candidate who would not antagonize the moderate antislavery voters in the Northern states. Moreover, the leading contender in the Republican party appeared

to be Senator William H. Seward of New York. His leadership in the Senate made him a formidable opponent. But the Republican leadership knew that the support of four crucial states—Indiana, Illinois, Pennsylvania, and New Jersey—were necessary to win the nomination. Seward's prospects in Illinois, Indiana, and Pennsylvania were uncertain. His description of the sectional controversy as an "irrepressible conflict" had cast him as too radical for many and his support of Catholics had alienated many former "Know-Nothings" who were needed to carry Pennsylvania.

Lincoln picked a group of close friends to serve as his campaign managers. Judge David Davis led the group, joined by other lawyers Leonard Swett, Norman B. Judd, Jesse Fell, and Orville H. Browning. They clinched Lincoln's nomination at the state convention and began to solicit national delegates for their man. Using a clever stratagem, Davis urged other state delegations to accept Lincoln as their second choice should there be no clear front-runner. The choice of Chicago as the site of the Republican national convention also gave Lincoln a home field advantage. His friends packed the galleries with Lincoln supporters, often enlisting the services of champion hogcallers noted for their prodigious lung power. Deals and promises were made. In the end, Seward's support was not great enough to win him the nomination. Lincoln's moderate views on slavery and his support of the Republican platform proved more acceptable to party leaders.

"Lincoln and Hamlin Wide-Awake" banner.
(Illinois State Historical Library)

Wide-Awake oil torch in the shape of an American eagle.
(Illinois State Historical Library)

Woman's Wide-Awake parade uniform, blue oilcloth.
(Illinois State Historical Library)

[Abraham Lincoln], plaid lap robe owned by Abraham Lincoln.
(Illinois State Historical Library)

In the fall of 1860, Republican "Wide-Awake" clubs sprang up throughout the northern states to work for Lincoln's election. The Wide-Awakes carried torches and wore a uniform made of oilcloth to protect the wearer from the dripping coal oil. A rally might feature two or three hours of speeches followed by a barbecue. At dusk, the Wide-Awakes would don their uniforms, light their torches and parade with banners around the town square, singing campaign songs.

## The Republican Candidate, 1860

*"Let us have faith that right makes might"*

According to a time-honored American political tradition, presidential candidates did not actively seek the office. Lincoln strictly observed the tradition, declining to campaign or speak on his own behalf. He also avoided the possibility of making mistakes and playing into the hands of the opposition. Throughout the election, Lincoln was asked by reporters, Southerners, abolitionists, and others to clarify his positions or to address a particular concern. Except for minor matters such as confirming that his name was "Abraham," not "Abram," he refrained from making any statements, advising his questioners to consult his published speeches or the Republican platform.

The campaign of 1860 was a combination of pageantry and practical politics. Republicans and commercial image-makers alike took up the task of presenting Lincoln to the nation through campaign biographies and party tracts, slogans, photographs and prints, songs and music, and orchestrated rallies and events to bolster party loyalty and spirits. The Republican platform, Lincoln's speeches, and party-approved campaign biographies of Lincoln and his running mate Hannibal Hamlin were distributed throughout the Northern states. These publications were often translated into German, Dutch, French, Spanish, and even Welsh to provide information on Republican policies to large immigrant settlements throughout the urban East, the rural Midwest, and California. Lincoln had been dubbed "The Rail Splitter" at the Republican state convention in Decatur, Illinois, and the nickname was widely used by the press. It stressed Lincoln's frontier beginnings and comported well with notions of his honesty. It also supported the view that Lincoln was not an established national politician but an unknown from Illinois. Political ribbons and buttons proudly displayed the faces of Lincoln and Hamlin. Rallies were organized to advance the views of the Republican Party and the can-

didacy of Abraham Lincoln. "Wide-Awake clubs" were created to orchestrate public displays of Republican pageantry.

On a practical level, the electoral math was clear to political strategists. Free states comprised a majority of votes in the electoral college, where the next President would be chosen. This Northern preponderance further sharpened sectional hostilities. The Republicans could win the presidency without winning the Southern states, if they could sweep the North. Republican leaders worried, however, that a "fusion" ticket—Lincoln's opponents uniting behind a single candidate—would prevent their capturing New York, Pennsylvania, Rhode Island, and New Jersey.

Lincoln faced three opponents for the presidency. His old rival Stephen A. Douglas represented the Northern wing of the divided Democratic party. Strongly proslavery John C. Breckinridge was standard bearer for the Southern Democrats. Last was John Bell, who ran as a moderate under the "Constitutional Union" banner. Months before the election, Douglas understood the Republicans had the electoral votes to win. Breaking tradition, Douglas actively campaigned in the South, warning Southerners that secession would not be tolerated, but assuring them that they had nothing to fear from a Lincoln presidency. Douglas's efforts at reconciliation were aimed at building his own base of support for a presidential bid in 1864.

When Americans went to the polls on November 6, 1860, the results revealed what many had guessed—Lincoln was to be the next President. Even though Lincoln received only thirty-nine percent of the popular vote (1,866,452), he had 180 electoral votes, more than the required number. Lincoln's opponents divided the remainder: Douglas received 1,376,957 popular and 12 electoral votes; Breckinridge received 849,781 popular and 72 electoral votes; and Bell received 588,879 popular and 39 electoral votes. Had the opposition

not been divided, Lincoln's success in sweeping the Northern states with large electoral votes would have still given him victory in the electoral college. His lopsided sectional victory, however, reinforced fears in the South that not only slavery, but its way of life would be threatened by the administration of the first avowedly antislavery candidate to be elected President.

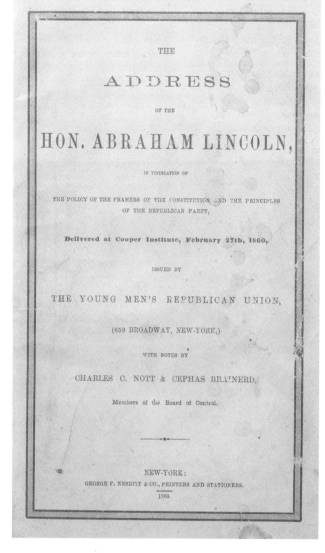

*The Address of the Hon. Abraham Lincoln, in Vindication of the Policy of the Framers of the Constitution and the Principles of the Republican Party…27th February 1860* (New York, 1860). (Huntington Library)

The Cooper Union speech established Lincoln as a powerful spokesman for the policy of opposing the spread of slavery. Lincoln argued that the nation's Founding Fathers had regarded slavery *"as an evil not to be extended"* into new territories. Thus the overriding goal of the Republican party— to prevent the spread of slavery into the western territories – was both constitutional and true to the ideals of the American Revolution. Lincoln's first major success before an Eastern audience confirmed him as a contender for his party's presidential nomination.

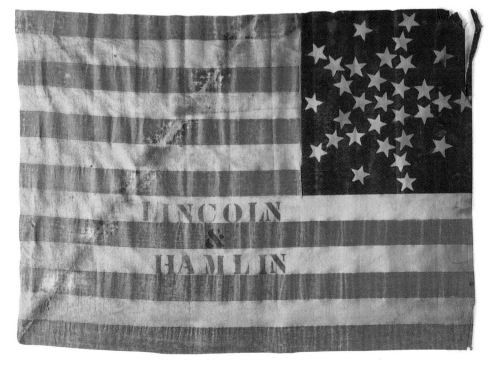

"Lincoln & Hamlin" flag from the 1860 campaign. (Taper Collection)

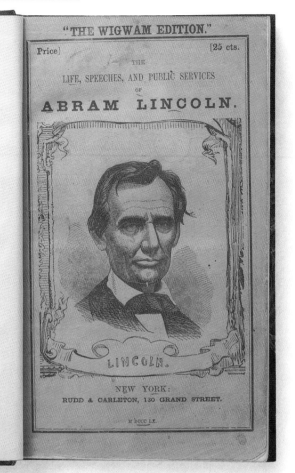

*The Life, Speeches, and Public Services of Abram Lincoln, Together with a Sketch of the Life of Hannibal Hamlin. Republican candidates for the Offices of President and Vice-President of the United States* (New York, 1860). (Huntington Library)

Americans were eager for any news of the Republicans' dark-horse presidential nominee, the little-known former Congressman from Illinois. "The Wigwam Edition" was the first campaign biography of Abraham Lincoln. It came out two weeks after Lincoln's nomination and sold 12,000 copies in its first week.

Currier & Ives, *Honest Abe taking them on the Half-shell.* Lithograph. (New York, 1860). (Huntington Library)

A delighted Lincoln prepares to devour his two Democratic rivals in this cartoon from the 1860 presidential campaign. In 1860 the Democratic party had split along sectional lines over the issue of slavery. Lincoln's old rival, Senator Stephen Douglas, ran as candidate for the party's Northern wing. Douglas's stand on slavery was considered moderate – or "soft shell." The "hard shell" candidate, proslavery John Breckinridge, was the standard bearer for the Southern Democrats.

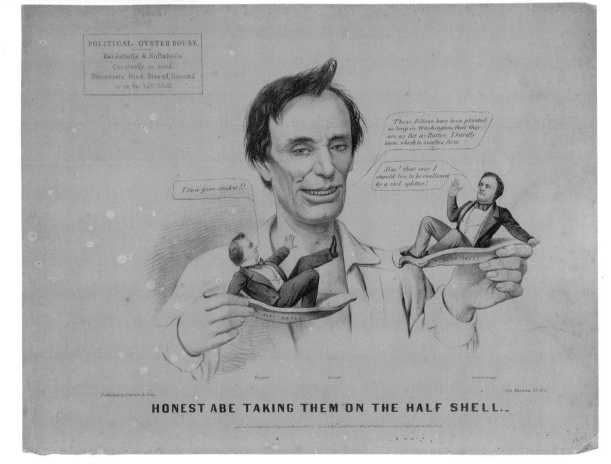

Abraham Lincoln, autograph letter signed to Joshua R. Giddings, June 26, 1860. (Taper collection)

Candidate Lincoln honored an old American political tradition when he did not actively campaign for the presidency. In this letter, Lincoln thanked a supporter for suggesting that he not speak out on policy issues before the election. Lincoln added that

*"If I fail, it will be for lack of ability, and not of purpose."*

But Lincoln's silence may have increased Southern suspicions that he was a "black Republican," a radical abolitionist determined to attack slavery in the South.

# CHARLESTON

# MERCURY

## EXTRA:

---

*Passed unanimously at 1.15 o'clock, P. M., December 20th, 1860.*

### AN ORDINANCE

*To dissolve the Union between the State of South Carolina and other States united with her under the compact entitled "The Constitution of the United States of America."*

We, the People of the State of South Carolina, in Convention assembled, do declare and ordain, and it is hereby declared and ordained,

That the Ordinance adopted by us in Convention, on the twenty-third day of May, in the year of our Lord one thousand seven hundred and eighty-eight, whereby the Constitution of the United States of America was ratified, and also, all Acts and parts of Acts of the General Assembly of this State, ratifying amendments of the said Constitution, are hereby repealed; and that the union now subsisting between South Carolina and other States, under the name of "The United States of America," is hereby dissolved.

---

## THE

# UNION

## IS

# DISSOLVED!

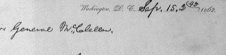

Washington, D. C. Sep. 15, 2 45 1862.

Major General McClellan.

Your despatches of to-day received. God bless you, and all with you. Destroy the rebel army, if possible.

A. Lincoln

# The Secession Crisis

*"Peace, or a sword?"*

On March 4, 1861, Abraham Lincoln was inaugurated President of a divided nation, a nation poised on the brink of its most tragic ordeal. Southerners regarded the Republican candidate's election as both an insult to Southern honor and a "declaration of unceasing war against slavery." It appeared that there were now two American nations, two hostile countries that could no longer live together under a single government. Before long, Southern fire-eaters saw to it that there were indeed two nations. Led by South Carolina, the seven states of the lower South quickly left the Union in the weeks following Lincoln's election. With remarkable swiftness, these seven—South Carolina, Mississippi, Florida, Georgia, Alabama, Louisiana, and Texas—united as the Confederate States of America, drafted a constitution, created a government, and inaugurated Jefferson Davis as their president. All this before Abraham Lincoln had even completed his journey from Springfield to Washington for his own inauguration.

The new Confederate constitution recognized state sovereignty and an unrestricted right to hold slaves. The Confederacy was defiantly founded on slavery, racism, and inequality. In 1858, Abraham Lincoln had affirmed that "the negro is included in the word 'men' used in the Declaration of Independence. I believe the declaration that 'all men are created equal' is the great fundamental principle...that negro slavery is violative of that principle...." In stark contrast, one of the Confederacy's founders declared in 1861 that "our new government is founded upon exactly the opposite idea of equality of the races....Its

cornerstone rests upon the great truth that the negro is not equal to the white man; that slavery...is his natural and normal condition."

As presidential candidate and president-elect, Lincoln had made no public statements. He believed that his published speeches and the Republican party platform fully presented his positions. Lincoln had of course said that he believed slavery was wrong and should not be extended into new territories. But he had also said that he had no intention of interfering with slavery in the states where it already existed. Lincoln was one of many in the North who discounted the likelihood that the slave states would really leave the Union. He was inclined to think that secession talk was an empty threat, calculated to frighten the North into making more concessions to slave power. Moreover, Lincoln had won the presidency in a fair election. He saw no reason to surrender his party's antislavery principles. So when some politicians in Washington vainly tried to keep the South loyal with compromises that would have allowed slavery to expand into new territories, the president-elect in Springfield would have none of it. "Hold firm," he said, "as with a chain of steel."

The speech the new president gave after taking the oath of office that blustery March day was the most important inaugural address in the republic's history. Lincoln had written his first draft in Springfield. At the urging of two trusted advisers, he had toned down some of the tougher passages, those that seemed to threaten the use of force against the South. Still, President Lincoln's carefully chosen words were tough as well as conciliatory. He

United States flag flown over Lincoln White House.
(Huntington Library)

"THE UNION IS DISSOLVED!" *Charleston Mercury* Extra and Ordinance of Secession, December 20, 1860.
(Huntington Library)

Convinced that slavery and the Southern way of life were threatened by Lincoln's election, South Carolina, the most radical of the lower South slave states, voted to leave the Union in December 1860.

Abraham Lincoln, autograph letter signed to George B. McClellan, September 15, 1862.
(Illinois State Historical Library)

Abraham Lincoln understood better than many of his generals that to win the war the North had to destroy the Southern armies, not just capture Southern cities and territory. In this letter, Lincoln urged General McClellan to *"Destroy the rebel army."*

37

began by promising again not to interfere with slavery. But he insisted that secession was a constitutional impossibility—"the Union of these States is perpetual." Abraham Lincoln understood that secession, the permanent rending of the Union, meant the ruin of the American experiment in self-government, and the doom of the great promise that America offered the world. At his inauguration beneath the unfinished dome of the U.S. Capitol, Lincoln pleaded with Americans to keep the promise alive.

Though he spoke of peace on inauguration day, President Lincoln was willing to risk war to save the Union. War was probably inevitable, since the extremists of the lower South would settle for nothing less than independent nationhood for their new slave empire. On April 12, 1861, Confederate cannon opened fire on the small U.S. garrison at Fort Sumter, the galling symbol of federal authority in Charleston harbor. Sumter surrendered after a two-day bombardment. The next day President Lincoln called for 75,000 troops for the fight to save "our National Union, and the perpetuity of popular government." The upper South—Virginia, North Carolina, Tennessee, and Arkansas—promptly seceded, greatly increasing the strength of the Confederacy. The American Civil War had begun. In the innocence of 1861, most expected it would be over in two or three months.

## Commander in Chief

### *"Destroy the Rebel Army"*

Abraham Lincoln was a war President. He presided over the greatest war Americans ever fought. In his Second Inaugural Address Lincoln spoke of "the progress of our arms, upon which all else chiefly depends." Indeed, the two achievements for which Lincoln is best remembered—saving the Union and freeing the slaves—were both the result of military success. The judgment of history is that Abraham Lincoln became a superb war leader. He came to the great task with little preparation. Lincoln's only firsthand military experience had been a few weeks in the Illinois militia during a small Indian uprising in 1832. He attained the rank of captain, but saw no action. Yet Abraham Lincoln became the commander in chief of the largest army and navy on earth. As the Union's chief executive he also directed the enormous war effort of an entire nation mobilized in history's first modern war. And before Lincoln found in Ulysses S. Grant a top commander worthy of his confidence, the President often acted as his own general-in-chief.

Lincoln brought to the presidency high intelligence, the ability to see the big picture, and an unshakable determination to preserve the experiment in freedom that was the United States. From the beginning, the president possessed a sweeping vision that gave him an unrivaled grasp of a few fundamentally important features of the great contest between the Union and Confederacy. He knew that to win the war, the United States had to conquer the South. But the Confederacy needed only to avoid being conquered to gain its national independence. Better than most of his generals, Abraham Lincoln understood that the goal had to be the destruction of Southern armies, not merely the capture of some Southern cities and territory.

Just a week after the attack on Fort Sumter, Lincoln recognized the economic dimensions of modern war when he declared a naval blockade against the Confederacy. He was also quick to see the strategic importance of the west—the vast military arena of the Mississippi Valley where, it could be said, the North really won the Civil War. And Lincoln understood that Northern superiority in men and material by itself could not defeat the enemy, not so long as Union forces were committed to battle piecemeal, allowing the Confederates to counter by concentrating their smaller armies. Lincoln saw that the North needed to attack on several fronts and in various theaters at the

same time. These ideas ran counter to the accepted military wisdom of 1860. It took Abraham Lincoln a long time to find commanders who understood the need for coordinated attacks. The kind of war Lincoln envisioned required the creation of a national command system to direct and coordinate the campaigns of many armies fighting in theaters that extended over thousands of miles. After Grant assumed overall command of the Northern armies in March 1864, the president took a less active role, but only because he had identified and raised to high command a group of generals who thought as he did.

Wooden inkwell used by Abraham Lincoln to write his First Inaugural Address.
(Illinois State Historical Library)

Abraham Lincoln used this old wooden inkwell to write the most important inaugural address ever given by a new president of the United States. In his carefully-worded speech, Lincoln pleaded for the preservation of the Union. But by the time Lincoln took office, Southerners had already declared that the Union was no more. Seven slave states had united as the Confederate States of America. Though Abraham Lincoln pleaded for peace, he left no doubt that he would oppose Southern secession. *"The Union is unbroken,"* he said firmly.

Abraham Lincoln, autograph letter signed to Alexander H. Stephens, December 22, 1860.
(Huntington Library)

Two days after South Carolina left the Union, Lincoln promised again not to interfere with slavery in the South.

*"Do the people of the South really entertain fears that a Republican administration would, directly or indirectly, interfere with their slaves, or with them, about their slaves?*

*…there is no cause for such fears— The South would be in no more danger in this respect, than it was in the days of Washington—I suppose, however this does not meet the case—You think slavery is right, and ought to be extended; while we think it is wrong and ought to be restricted—That I suppose is the rub…."*

Abraham Lincoln, autograph
letter signed to Lyman Trumbull,
December 10, 1860.
(Huntington Library)

President-elect Lincoln opposed any
compromise with Southern slave-
holders that would have allowed
slavery to spread into new territories.
When Southerners threatened to
leave the Union after Lincoln's election,
some Northern politicians proposed
compromises to placate the South
by allowing slavery to expand. But in
this letter Lincoln insisted:

*"Let there be no compromise on the
question of extending slavery—If there
be, all our labor is lost, and, ere long,
must be done again...Have none of it—
Stand firm. The tug has to come, &
better now, than any time hereafter...."*

Abraham Lincoln, autograph letter
signed to Gideon Welles, March
29, 1861. (Huntington Library)

Lincoln knew he risked war when he
refused to surrender the little Federal
garrison holding out at Fort Sumter.
After a sleepless night, the new Presi-
dent decided to re-supply the
besieged fort in the harbor of Charles-
ton, South Carolina. On March 29,
1861, Lincoln boldly penned these
orders for *"an expedition... by sea."*
The waiting ended on April 12, 1861,
when Southern artillery opened fire
on Sumter. The Civil War had begun.

*Union Ball 1861* (invitation to Abraham Lincoln's inaugural ball March 4, 1861).

(Illinois State Historical Library)

The newspapers called Lincoln's inaugural ball a "brilliant occasion," but the brilliance was overshadowed by the gravest constitutional crisis the United States had ever faced. Soldiers guarded the hall where guests gathered to celebrate the new president's inauguration. The ceremony itself had taken place in a capital alarmed by rumors of assassination and Southern invasion. There were riflemen on the rooftops, cavalry and artillery in the streets, as Abraham Lincoln took the oath of office.

Abraham Lincoln, autograph letter signed to George B. McClellan, October 24, [i.e., 25] 1862.

(Illinois State Historical Library)

*"I have just read your dispatch about sore tongued and fatiegued horses. Will you pardon me for asking what the horses of your army have done since the battle of Antietam that fatigue anything?"*

Lincoln fired General McClellan about two weeks after sending him this stinging rebuke.

Throughout 1862, the people of the North hoped that McClellan would defeat the Confederate army and bring the Civil War to an early end. McClellan's failure to do so prolonged the war and recast it into *"a remorseless revolutionary struggle"* a total war that would destroy slavery and the Southern way of life.

41

Executive Mansion
Washington, April 30. 1864

Lieutenant General Grant.

Not expecting to see you again before the Spring campaign opens, I wish to express, in this way, my entire satisfaction with what you have done up to this time, so far as I understand it, The particulars of your plans I neither know, or seek to know. You are vigilant and self-reliant; and, pleased with this, I wish not to obtrude any constraints or restraints upon you. While I am very anxious that any great disaster, or the capture of our men in great numbers, shall be avoided, I know these points are less likely to escape your attention than they would be mine— If there is anything wanting which is within my power to give, do not fail to let me know it.

And now with a brave Army, and a just cause, may God sustain you.

Yours very truly
A. Lincoln

opposite: Abraham Lincoln, autograph letter signed to Ulysses S. Grant, April 30, 1864.
(Huntington Library)

Abraham Lincoln found in Ulysses S. Grant a general who understood that the Civil War was a total war to force unconditional surrender on the Confederates. By the time Grant took command of all the Northern armies in early 1864, the war had become Lincoln's *"mighty scourge of war"*— a war to destroy slavery, Southern society and the Confederate government. Lincoln sent Grant's vast army into battle with the words:

*"And now with a brave Army, and a just cause, may God sustain you."*

Abraham Lincoln, autograph note signed, May 28, 1864, pardon for desertion written on a bandage.
(Taper Collection)

*"Let this boy be pardoned for any supposed desertion, and discharged from the service."*

Little is known of the circumstances of this unusual Lincoln document, a pardon for a soldier written out on a scrap of gauze bandage. It was probably written during a visit to a military hospital. Lincoln's many, well-known acts of mercy to individual soldiers have tended to obscure the fact that the Civil War president was a shrewd and remorseless commander in chief, utterly dedicated to the destruction of his Confederate foes.

John Rogers, "The Council of War," 1868 (plaster group of Lincoln, General U.S. Grant and Secretary of War Edwin Stanton). Robert Todd Lincoln's copy.
(Taper Collection)

President Lincoln, a masterful politician and strategist; his stern, tireless Secretary of War; and the combative 42-year-old general-in-chief made up a team that worked to bring the North's overwhelming resources to bear against the South, grinding the Confederacy to unconditional surrender.

# President Lincoln's Emancipation Proclamation

Abraham Lincoln,
President of the **United States**,
by virtue of the power in me vested
as Commander in Chief of the Army, and
Navy of the **United States**, in time of
actual armed rebellion against the authority
and government of the **United States**, and as
ing said rebellion, do on this first day of January
eight hundred and sixty three, and in accordance with my p
full period of one hundred days from the day of the first above
and parts of States wherein the people thereof respectively are this day
following, to wit: **Arkansas, Texas, Louisi** except the p
Jefferson, **St.John, St.Charles, St.James, Ascension, Ass**
**St.Martin,** and **Orleans,** including the city of New **Orleans — Miss**
**South Carolina, North Carolina,** and **Virginia** — except the forty
and also the counties of **Berkeley, Accomac, Northampton, Elizabeth C**
including the cities of **Norfolk** and **Portsmouth,** and which excepted
as if this proclamation were not issued.

And by virtue of the power and for the purpose aforesaid
persons held as slaves within said designated States and
shall be free; and that the executive government of the **U**
and naval authorities thereof will recognize and maintain th

And I hereby enjoin upon the people so declared
unless in necessary self defense; and I recommend to them
labor faithfully for reasonable wages.

And I further declare and make known that such perso
be received into the armed service of the **United States,** to garrison forts, pos ns, and other
places, and to man vessels of all sorts in said service.

And upon this, sincerely believed to be an act of justice, warranted by the **Constitution,**
upon military necessity, I invoke the considerate judgment of mankind and the gracious favor of

## Almighty God

Abraham Linco

I never knew a man who wished
to be himself a slave. Consider if
you know any good thing, that no
man desires for himself.

A. Lincoln

March 22. 1864

# War for the Union, 1861–1862

## "My paramount object is to save the Union"

In a sense Abraham Lincoln fought two civil wars, one following the other. The North lost the first civil war and won the second. The first war lasted from the attack on Fort Sumter through the end of 1862. It was a war of limited political and military objectives, fought to restore the Union as it had been—the old Union made up of states both slave and free. Had the North somehow prevailed during the first year and a half of the Civil War—if, for instance, McClellan had defeated Lee and captured Richmond in the summer of 1862—the old Union might have been restored. Slavery might have survived in the South, at least for a time, and the course of American history would have been fundamentally different. But the North did not win the first war, and so the Civil War evolved into another, far greater, war, an unlimited war for Union and freedom. This war brought about the birth of a new American nation through the complete destruction of slavery, the overthrow of the South's slave-based society, and the unconditional surrender of the rebelling Confederate states.

Historians have described limited war as one in which the belligerents fight to force a negotiated settlement on the enemy by winning battlefield victories and occupying territory. While there may be a winner and loser, a limited war usually ends in a peace treaty that leaves the societies and governments of both sides intact. In contrast, an unlimited war ends not with negotiated peace, but with the loser's unconditional surrender. If limited war is a war of army against army, unlimited war pits society against society. Victory in an unlimited war usually means the destruction of the enemy's government. During the first year and a half of the Civil War, Abraham Lincoln waged a limited war against the Confederate States of America. He did so for several reasons.

Although the republic had been torn apart by a war caused by slavery, immediate abolition remained a radical idea. The northernmost tier of slave states—Delaware, Maryland, Kentucky, and Missouri—those that bordered on the free states, had not followed the upper South into secession in April 1861. Yet Unionist sentiment in the border states was highly conditional. Many of the region's citizens would not support a war to destroy slavery. Lincoln believed that if the border states—particularly Maryland and Kentucky—went over to the Confederacy, the North could not win the war. There were also many in the North itself, Democrats and others, who would not fight for emancipation. Many feared the vast social and political dislocation that would result from giving freedom to some four million enslaved African Americans. To wage war, Lincoln needed the support of the loyal opposition in the North as much as he needed the border states. Moreover, until 1862, Lincoln believed, as he had throughout his pre-war political career, that the Constitution gave the federal government no power over slavery in the states where it existed. When two Northern generals issued battlefield proclamations freeing slaves in their theaters of the war, the president quickly overturned them. He did not intend, Lincoln said, to let the war "degenerate into a violent and remorseless revolutionary struggle."

Lincoln had long favored a gradual end to slavery, perhaps linked with colonization, that is, the re-settlement of African Americans in overseas colonies. The middle course he leaned toward during the first year and a half of the war included government-compensated emancipation. In 1861 and 1862, the president tried to enlist the support of the loyal slave states for plans to end slavery over a period of many years, with the federal government paying slaveholders for their human property. Such a plan, Lincoln believed, would assure that the border slave states would not join the Confederacy. It might also make it easier for the Confederate states to rejoin the Union.

But the border slave states rejected the president's gradual emancipation plans and, as 1862 dragged on without decisive victories on the battlefield, President Lincoln was one of many Americans who began to look at emancipation in a new light. By July 1862, Lincoln had come around to the idea that emancipation was "a military necessity, absolutely essential to the preservation of the Union. We must free the slaves or be ourselves subdued." To attack slavery, the president said, was to "strike at the heart of the rebellion."

The strategy of fighting a limited war to save the Union had failed. Abraham Lincoln decided to issue the Emancipation Proclamation.

## War for Union and Freedom, 1863–1865

*"New birth of freedom"*

The Emancipation Proclamation was the most revolutionary action ever taken by an American president. On January 1, 1863, it declared "forever free" all of the slaves in the Confederate states then in rebellion against the United States. The North's war aims were now expanded to include the destruction of slavery. Emancipation was both a weapon for winning the war and a reason for winning the war. Slavery was the cornerstone of the Confederacy. Emancipation would overturn that foundation. After the Proclamation, the North fought an unlimited war to destroy the Confederacy and bring the conquered Southern states back into the Union by unconditional surrender.

Military necessity had overcome Lincoln's reservations about the constitutionality of emancipation. Southern slaveholders had maintained for generations that the African Americans they held in bondage were a form of property. Very well then, said Lincoln, by both the rules of war and the laws governing civil insurrection, enemy property can be seized. The Emancipation Proclamation was an action Abraham Lincoln took "as Commander-in-Chief of the Army and Navy of the United States in time of actual armed rebellion against authority and government of

the United States, and as a fit and necessary war measure for suppressing said rebellion." This is why the proclamation did not free the slaves in areas already under Union control— Lincoln still believed he had no authority for such a step. And although the president had decided to issue the proclamation in July 1862, he waited until the North had successfully repelled a Confederate invasion at the battle of Antietam before revealing his intention. Even then, in September 1862, he gave the slaveholders a warning that emancipation would come in one hundred days—on January 1, 1863—if the South persisted in rebellion.

When he signed the final proclamation on January 1, 1863, Lincoln said, "If my name goes down in history, it will be for this act." The Emancipation Proclamation gave new coherence and moral loftiness to the Union war effort, added enormous strength to the Union armies through the enlistment of tens of thousands of African American soldiers, and dampened hope for diplomatic recognition of the Confederacy by the European powers. It also freed the man who issued it. In the words of historian James M. McPherson, the proclamation "liberated Abraham Lincoln from the agonizing contradiction between his 'oft-expressed *personal* wish that all men every-

where could be free' and his oath of office as president of a slaveholding republic." After the Emancipation Proclamation, the Union fought for the "new birth of freedom" which Abraham Lincoln so eloquently invoked at Gettysburg in November 1863.

Adalbert J. Volck, [The Baltimore Riot of April 19, 1861] c. 1861, etching. (Huntington Library)

In April 1861, a mob of pro-Southern Marylanders attacked Massachusetts troops passing through Baltimore on their way to defend Washington, D.C. Abraham Lincoln waged his war to save the Union from Washington, a national capital surrounded by the slave states of Virginia and Maryland. Lincoln believed that if Maryland and the other border slave states joined the Confederacy, the Union cause would be as good as lost.

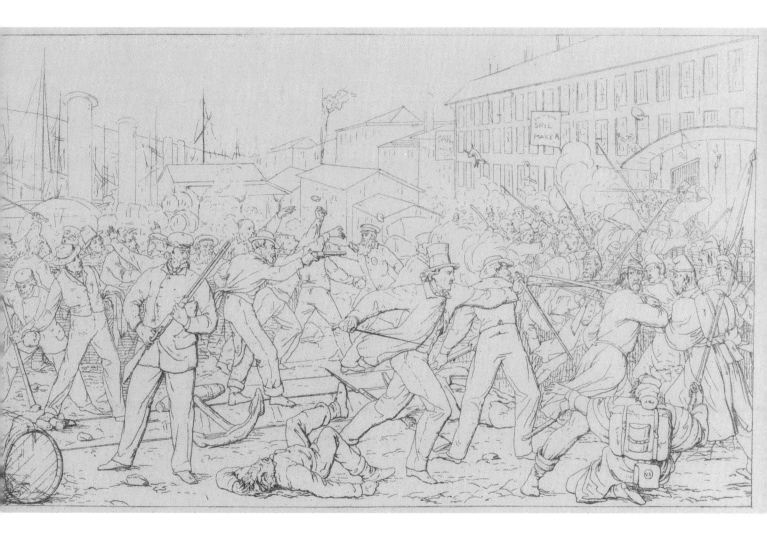

Abraham Lincoln, autograph letter signed to Kentucky Governor Beriah Magoffin, August 24, 1861.
(Illinois State Historical Library)

In a joke that summed up the importance of the border states to the Union war effort, Lincoln reportedly said, "I hope to have God on my side, but I *must* have Kentucky." In this letter to the pro-Southern governor of Kentucky, Lincoln refused to withdraw a Union army from the state. The President is determined, he writes, to support *"a majority of all the Union-loving people of Kentucky."*

Abraham Lincoln, letter signed to Orville H. Browning, September 22, 1861.
(Illinois State Historical Library)

In 1861, many of Lincoln's fellow Republicans protested when the president overturned a Union general's order freeing slaves in Missouri. But Lincoln had no choice. Emancipation might drive the border slave states into the Confederacy. Here Lincoln explained that freeing the slaves would lose Kentucky and,
*"I think to lose Kentucky is nearly the same as to lose the whole game. Kentucky gone, we cannot hold Missouri, nor, as I think, Maryland. These all against us, and the job on our hands is too large for us. We would as well consent to separation at once, including the surrender of this capitol."*

opposite top: Abraham Lincoln, autograph letter signed to Nathaniel Banks, March 29, 1863.
(Huntington Library)

By the war's end more than 180,000 African Americans—most of them former slaves—had served in the Union army. Without their courage, the North probably could not have won the Civil War. In this letter, Lincoln told a general charged with *"raising a colored brigade"* that
*"To now avail ourselves of this element of force, is very important, if not indispensable."*

Before deciding to issue his revolutionary Emancipation Proclamation, Abraham Lincoln considered a more conservative approach to ending slavery. In 1861 and 1862, the president unsuccessfully proposed plans for freeing the slaves over a period of many years, with the government paying slaveholders for their human property. Lincoln himself drafted this plan for emancipation in the loyal slave state of Delaware. Under its terms, the last slaves in the state would not have been freed until 1893.

Under Lincoln's reconstruction plans, the former Confederate states had to abolish slavery before they could rejoin the Union. In this letter, Lincoln instructed his military governor in Arkansas to move ahead with a new state constitution which will outlaw slavery. The president gave the exact words he wanted used in the clauses abolishing slavery. Those clauses are set off by quotations in the middle of the page, beginning

*"There shall be neither slavery nor involuntary servitude...."*

# Life in the Lincoln White House

*"I happen to temporarily occupy this big White House"*

Many problems awaited the Lincolns at the White House, which was usually called the "Executive Mansion." Even before the Lincolns and their three sons left Springfield, dark portents of future troubles manifested themselves. Lincoln received poisoned food from Southern secessionists, as well as many death threats. Eastern socialites questioned whether Mary Lincoln, a Western woman, would be able to bring appropriate poise and dignity to her new role as First Lady. The White House was sorely in need of repairs and remodeling, having been neglected for several administrations. Willie and Tad reveled in the reporters' attentions and willingly performed for the press. Robert, however, found the public spotlight distasteful and resented the newspapers dubbing him the "Prince of Rails." The intense public scrutiny as well as the heightened emotions brought on by the Civil War made any semblance of a normal family life impossible for the Lincolns.

Robert spent most of his time away at Harvard University. His brief visits to the White House came during school breaks and summer vacation. Willie and Tad were under the supervision of Julia Taft, a young woman with two small brothers, Bud and Holly, of similar age to the Lincoln boys. Her recollections provide vivid accounts of children full of energy, inquisitiveness, and occasional irreverence. The Lincoln boys, aided by Bud and Holly, provided their share of problems for the White House servants. On one occasion the boys found the pull cords to the White House call-bell system. By pulling on the cords the boys sounded bells throughout the building,

sending servants scurrying about only to find empty rooms. The playful atmosphere created by the Lincoln boys ended with the death of Willie on February 20, 1862. His death was keenly felt by the president, who had a special fondness for his third son. Mary Lincoln went into such a deep depression that many close friends believed she was inconsolable. Tad Lincoln was adrift without his older brother and playmate. Only with the passage of time did the Lincolns begin to overcome their grief. Lincoln immersed himself more deeply in his work. He became more protective of Tad, allowing the boy to interrupt Cabinet meetings and wreak havoc in the White House and the surrounding grounds. The president dismissed complaints that Tad needed a firmer hand and a demanding tutor arguing "Let him run, there's time enough yet for him to learn his letters and get poky. Bob was just such a little rascal, and now he is a very decent boy."

Mary Lincoln aspired to be one of the most famous First Ladies of the nineteenth century. She overcame the disdain of many Washington socialites and reporters by establishing a series of receptions, or levees, Marine band concerts on the White House grounds, elegant formal receptions, and dressing in the latest Paris fashions. Mary Lincoln was fluent in French and demonstrated the poise learned at the Lexington, Kentucky, finishing school she had attended as a girl. As the war progressed, Washington was filled with wounded soldiers and the president's wife was a regular visitor to the military hospitals, distributing fruit, flowers, and baked goods among the patients. From Elizabeth Keckley—the First

Photograph of William Wallace ("Willie") Lincoln, who died in the White House in 1862, cased with a lock of the boy's hair.
(Taper Collection)

Abraham Lincoln, photograph signed, taken by Alexander Gardner, August 9, 1863.
(Taper Collection)

*Philp's Washington Described. A Complete View of the American Capital....* (New York, 1861). Mary Lincoln's copy of the popular guide to Washington, with "Mrs. A. Lincoln" stamped in gold on cover.
(Taper Collection)

Engraved White House invitation, October 17, 1861. (Taper Collection)

[Mary Lincoln], ivory letter opener.
(Taper Collection)

[Mary Lincoln], silver soup spoons with "ML" monogram.
(Taper Collection)

[Mary Lincoln], pink bordered china tureen with "ML" monogram. (Taper Collection)

53

Lady's dressmaker who was herself a former slave—Mary Lincoln learned of the problems facing contrabands (the escaped slaves who risked their lives to cross military lines to freedom), and she became one of the strongest voices in support of the Contraband Relief Association.

Mary Lincoln's greatest triumph, the refurbishing of the White House, created a financial scandal. Congress had appropriated twenty thousand dollars to be used during the first Lincoln administration for repairs and purchases to reverse the years of neglect and wear. She took her task seriously, traveling to the finest stores in Washington, New York, and Philadelphia. Her purchases of various furnishings, including French wallpapers, plush floor coverings, Havilland porcelain, and Dorflinger crystal for 190 guests made a marked improvement in the style and comfort of the Executive Mansion. The cost, however, exceeded the appropriation by over $6,700. The president's wife had succeeded in overspending her four-year budget in less than a year. She tried to hide the fact from her husband, enlisting the assistance of the White House gardener, John Watt, and an adventurer named Henry Wikoff. Unbeknownst to Mary Lincoln, Wikoff was on the payroll of the leading Democratic newspaper, the *New York Herald*. The resulting intrigue led to the publication of portions of Lincoln's Annual Message to Congress in the opposition newspaper before it was delivered to Congress. The president and the Republicans were furious. A House judiciary committee discovered that the trail of evidence led to Wikoff and Watt. Mary Lincoln was implicated and Watt even tried to blackmail leading Republicans with alleged incriminating correspondence. The allegations led to the dismissal of Watt and the banishment of both Watt and Wikoff from the White House. Congressional Republicans eventually passed two special appropriations to cover the cost overruns.

Abraham Lincoln often felt like a prisoner in the Executive Mansion. The public had free access to the building and crowded the halls seeking special audiences with the president. Lincoln listened to the pleas for government appointments, the granting of government contracts, mothers seeking clemency for their sons under military death sentences, and widows requesting government pensions. Lincoln called these sessions with petitioners his "public opinion baths." He often fled to the War Department telegraph office about a block from the White House to learn the latest news from the battlefronts. The "Summer White House" was Anderson Cottage located at the Soldier's Home just outside Washington. It was here that Lincoln and his family escaped the stench and sickness brought on by the summer's stagnant sewage in the capitol city's putrid canals. Lincoln's tastes in dress, food, and entertainment were always modest. The demands of the war, the death of Willie, and Mary's obsessive spending and flirtation with spiritualism led Lincoln into his own inner world. He found occasional solace with story-telling, reading joke books, attending the theater, and playing with Tad. But the pressures of the office and family took their toll on the sixteenth president, as witnessed by the final 1865 photographs.

Abraham Lincoln, autograph note signed to J.E. Allen, April 7, 1864.
(Taper Collection)

Lincoln sent this note to the White House blacksmith.

*"Shoe Tad's horse for him."*

Abraham Lincoln, autograph note signed to John A. Dahlgren, October 14, 1862.
(Illinois State Historical Library)

John A. Dahlgren was chief ordnance officer for the Navy and the inventor of the Dahlgren howitzer. On October 14, 1862, Lincoln wrote,

*"Capt. Dahlgren may let 'Tad' have a little gun that he cannot hurt himself with."*

[Tad Lincoln] Brass Scale-model Dahlgren Boat Howitzer.
(Illinois State Historical Library)

The model Dahlgren Boat Howitzer given to Tad Lincoln. Dahlgren disabled the working model cannon by bending the firing pin before sending it to Tad.

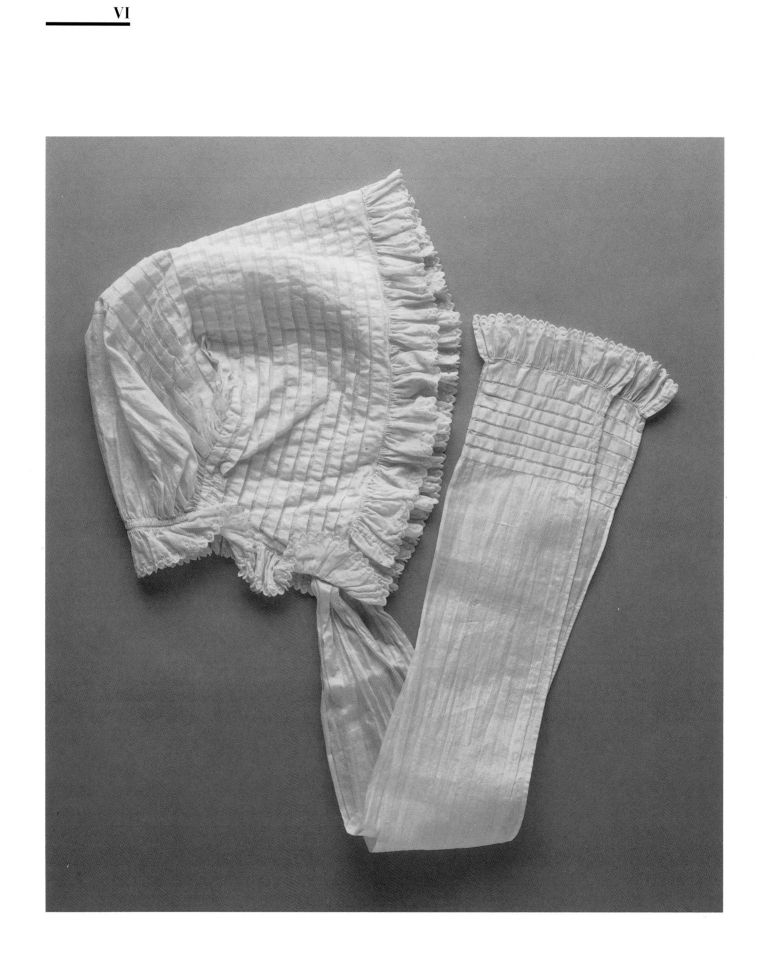

opposite page: [Mary Lincoln], linen nightcap. (Taper Collection)

this page: Chamber pot from the White House china service. The piece is from a large set ordered from Havilland porcelain and made in France. The pattern is "Solferino and Gold."
(Taper Collection)

[Mary Lincoln], coral necklace and earrings.
(Illinois State Historical Library)

[Mary Lincoln], ivory calendar/ memorandum book.
(Taper Collection)

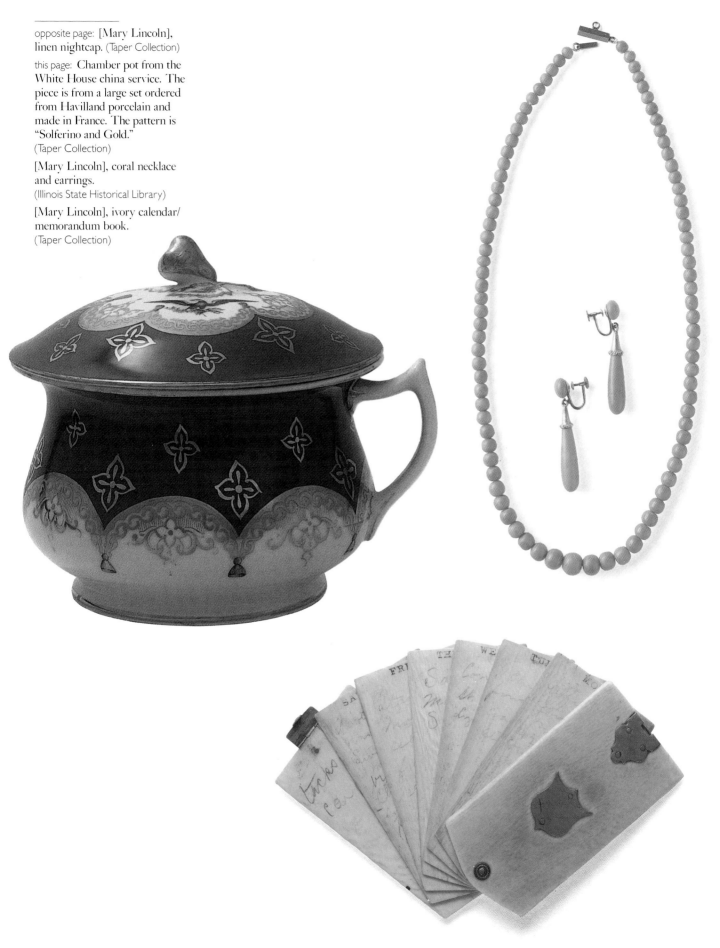

57

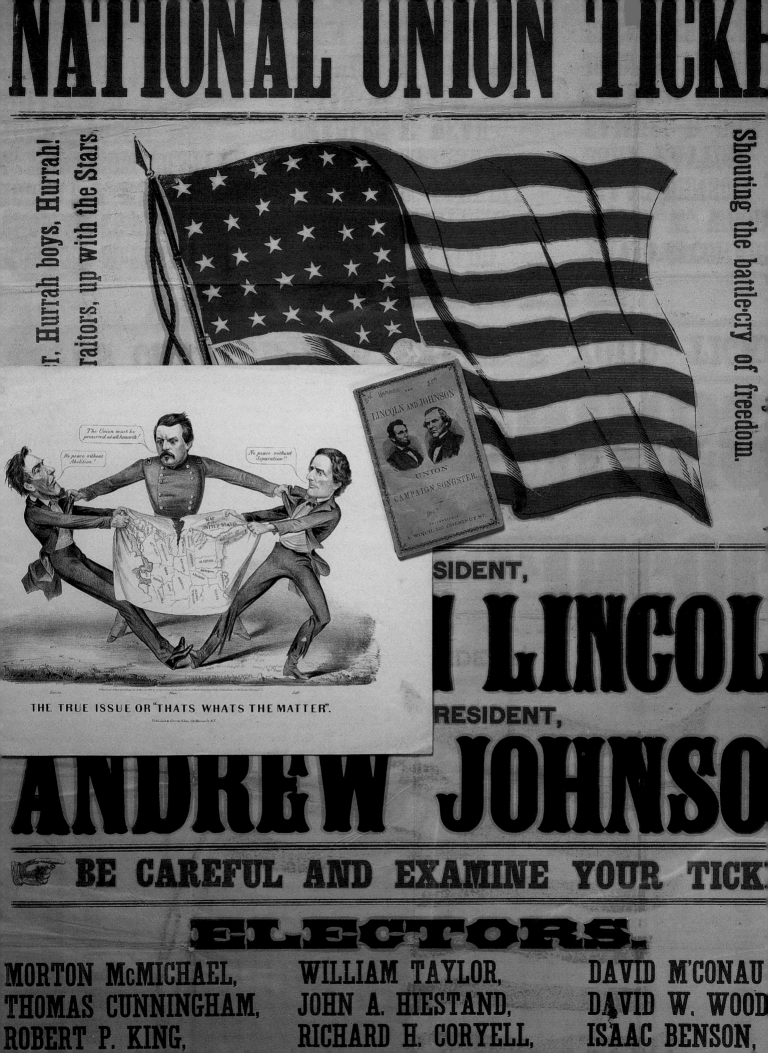

# Reelected in 1864

*"We cannot have free government without elections"*

In the gloomy summer of 1864, most observers agreed that Abraham Lincoln had little chance of winning a second term as president. Lincoln himself reckoned that he would be "beaten, and...*badly* beaten." The tide of war seemed to have turned against the North and the November election promised to be a referendum on the president's military leadership. Northern discouragement in the summer of '64 contrasted sharply with the hopefulness with which the year had begun. The Union had seemed on the brink of victory after the triumphs at Gettysburg and Vicksburg in July 1863. Hope had risen again in March 1864 when Ulysses S. Grant assumed command of the Northern armies and shifted his headquarters to Virginia to direct the war of destruction against Robert E. Lee's army. In Grant, Sherman, and Sheridan, Lincoln now had brilliant, tough-minded commanders, men determined to fight on to unconditional victory. The spring offensives of Grant in the east and Sherman in the west seemed to promise speedy defeat for the battered Confederacy.

Grant moved south in May. In the weeks that followed, the Army of the Potomac slugged it out with Lee's Army of Northern Virginia in a series of brutal battles. The war's most sustained and carnivorous fighting saw 65,000 Union soldiers killed, captured, or wounded. These horrific casualties seemed to have bought Grant nothing but costly stalemate—a trench warfare siege of Lee's army outside Richmond. Meanwhile, in the west, Sherman's offensive was stalled short of Atlanta. The Northern people began to despair that the cost of winning the war was

more than they could endure. "Our bleeding, bankrupt, almost dying country also longs for peace," one Northern editor told Lincoln. And peace in the summer of 1864 clearly meant Southern independence.

The Confederates sensed their great opportunity. War is seldom a purely military endeavor, particularly in a democracy. Battlefield events influence political trends, while politics sways military strategy. The 1864 election had become the pivot point on which the hopes of both sides turned. His defeat in the election, Lincoln believed, would translate into defeat of the Northern cause in the war. In August the president bleakly predicted just such an outcome: "...it seems exceedingly probable that this Administration will not be re-elected. Then it will be my duty to so co-operate with the President elect, as to save the Union between the election and the inauguration, as he will have secured his election on such ground that he can not possibly save it afterward." The Confederates agreed with Lincoln's assessment. If they could hold out until Lincoln lost the election in November, they would gain national independence. Robert E. Lee said that if the Southern armies were "successful this year, next fall there will be a great change in public opinion in the North. The Republicans will be destroyed.... We have only therefore to resist manfully." Lee's men had long since proven themselves capable of such resistance.

The Republicans themselves were divided. Some hoped to find another candidate. Nevertheless, in June the Republican party, calling itself the "Union" party, nominated Abraham

*National Union Ticket*, campaign poster, color lithograph (Philadelphia, 1864). (Huntington Library)

In August 1864, it seemed certain that Abraham Lincoln would be defeated in his bid for reelection. But by the end of the summer, Union victories like the capture of Atlanta had given the Republicans new strength. In November Lincoln became the first President in more than thirty years to win a second term.

*The Lincoln and Johnson Union Campaign Songster* (Philadelphia, 1864). (Illinois State Historical Library)

The Republicans campaigned in 1864 as the "Union" party. The choice of former Democrat Andrew Johnson for Vice President underscored the claim that the ticket united both Republicans and Democrats in a war to save the Union.

Currier & Ives, *The True Issue...* Lithograph (New York, 1864). (Huntington Library)

General George McClellan was the Democrats' 1864 presidential candidate. This cartoon illustrates a charge the Democrats made against Lincoln—that the president wanted to abolish slavery more than he wanted to save the Union.

Lincoln. The platform called for the unconditional surrender of the Confederacy and an amendment to the Constitution to outlaw slavery in the United States forever. The Democrats' platform, in contrast, advocated a negotiated peace and the protection of slavery in the South. The Democratic nominee was General George B. McClellan. In a campaign polluted by racism the Democrats accused Lincoln of stubbornly fighting an unwinnable war and sacrificing the lives of hundreds of thousands of white men to gain the freedom of black slaves. It looked like McClellan would be the next president. But then suddenly the thrilling news that Sherman had captured Atlanta transformed the political landscape.

That victory, as well as those gained by Northern forces in other theaters, gave new life to Lincoln's campaign. On November 8, 1864, Abraham Lincoln became the first American president to win a second term since Andrew Jackson's reelection in 1832. Two days later he told supporters that "we cannot have free government without elections; and if the rebellion could force us to forego, or postpone a national election, it might fairly claim to have already conquered and ruined us. . . . The election . . . has demonstrated that a people's government can sustain a national election, in the midst of a great civil war. Until now it has not been known to the world that this was a possibility."

## Victory

*"Liberty and Union,
Now and Forever"*

Union victory, Confederate defeat in the Civil War were by no means inevitable. The balance swung back and forth for nearly four years. If the North had the advantage in manpower and resources, the Confederacy also possessed powerful advantages. To win the war, the North had to conquer the South. But the Confederacy needed only to avoid being conquered to gain its national independence. Yet the North won.

Historians have advanced a good many explanations for Northern victory. These include the superior resources of the North, timely victories on the battlefield, lack of unity among the Confederates themselves, and emancipation and the enlistment of African American soldiers. Many also credit the inspired war leadership of Abraham Lincoln. His strategic vision in waging a total war, fought to unconditional victory, did much to doom the Confederacy. Under Lincoln's leadership war became revolution. The war to restore the old Union of free and slave states became a revolution to destroy slavery and create a new American nation, a nation dedicated to "a new birth of freedom."

After Lincoln issued the Emancipation Proclamation, the declared war aims of the

two rival governments were so fundamentally opposed that no negotiated peace was possible. The Confederacy fought for the independence of a nation founded on the institution of slavery. Lincoln's goals—the restoration of the Union and the abolition of slavery—amounted to national destruction, the unconditional surrender of the Confederate States of America. "There is now no possible hope of reconciliation with the rebels," a top Union commander wrote in early 1863. "There can be no peace but that which is forced with the sword." Lincoln was just as emphatic. In his last State of the Union address Lincoln said of Confederate President Jefferson Davis: "He would accept nothing short of severance of the Union—precisely what we will not and cannot give. . . . He cannot voluntarily reaccept the Union; we cannot voluntarily yield it. Between him and us the issue is distinct, simple, and inflexible. It is an issue which only can be tried by war; and decided by victory." Jeff Davis concurred: "We are fighting for INDEPENDENCE and that, or extermination, we will have." Many Confederates echoed their president when they defiantly vowed to "die in the last ditch" rather than surrender to the Yankees and their "nigger allies."

Estimated Electoral Vote 1864
Three weeks before Election

Office U. S. Military Telegraph,
WAR DEPARTMENT,

Washington, D. C. October 13th 1864.

| Supposed Copperhead Vote. | | Union Vote. for Lincoln | |
|---|---|---|---|
| New York | 33 | New England States | 39 |
| Penn | 26 | Michigan | 8 |
| New Jersey | 7 | Wisconsin | 8 |
| Delaware | 3 | Minnesota | 4 |
| Maryland | 7 | Iowa | 8 |
| Missouri | 11 | Oregon | 3 |
| Kentucky | 11 | California | 5 |
| Illinois | 16 | Kansas | 3 |
| | 114 | Indiana | 13 |
| | | Ohio | 21 |
| | | W. Virginia | 5 |
| | | | 117 |
| | | Nevada | 3 |
| | | | 120 |

But in the end most Confederates did surrender. Northern power joined to Northern will proved too much for the Confederate States. In the spring of 1865, the Southern armies melted away, more from desertion than battle losses. Lincoln's reelection had been a mandate, clear for all to see, for his policies of fighting the war through to unconditional victory and ending slavery forever through an amendment to the Constitution. The president worked to push the Thirteenth Amendment through Congress early in 1865. It became a part of the U.S. Constitution when it was ratified by the states in December 1865. By then the Civil War was over and Abraham Lincoln was dead. The Thirteenth Amendment declares simply that:

*"Neither slavery nor involuntary servitude... shall exist within the United States...."*

EXECUTIVE MANSION,
Washington, D. C., Aug 10th, 1863.

I, ABRAHAM LINCOLN, President of the United States of America, and Commander-in-chief of the Army and Navy thereof, having taken into consideration the number of volunteers and militia furnished by and from the several States, including the State of *New York*, and the period of service of said volunteers and militia since the commencement of the present rebellion, in order to equalize the numbers among the Districts of the said States, and having considered and allowed for the number already furnished as aforesaid, and the time of their service aforesaid, do hereby assign *Two Thousand and Fifty (2050)* as the first proportional part of the quota of troops to be furnished by the *2nd* DISTRICT OF THE STATE OF *New York* under this, the first call made by me on the State of *New York*; under the act approved March 3, 1863, entitled "An Act for Enrolling and Calling out the National Forces, and for other purposes," and, in pursuance of the act aforesaid, I order that a draft be made in the said *2nd* DISTRICT OF THE STATE OF *New York* for the number of men herein assigned to said District, and FIFTY PER CENT. IN ADDITION.

IN WITNESS WHEREOF, I have hereunto set my hand and caused the seal of the United States to be affixed.

Done at the City of Washington, this *tenth* day of *August*, in the year of our Lord one thousand eight hundred and sixty-three, and of the independence of the United States, the eighty-eighth.

*Abraham Lincoln*

Abraham Lincoln, document signed, August 10, 1863. Draft call for New York volunteers.
(Taper Collection)

The draft and Lincoln's war against slavery met with angry resistance throughout the North. Vowing that they would not "fight to free the nigger," thousands of New York City's poor took to the streets in July 1863 to protest the draft in the bloodiest urban rioting in U.S. history. The mobs burned draft offices and attacked any African Americans unlucky enough to be caught in the streets. The near-rebellion in the North's largest city was put down by veteran troops hurried in from the Gettysburg battlefield.

Abraham Lincoln, autograph document, "Estimated Electoral Vote 1864 three weeks before Election," October 13, 1864.
(Huntington Library)

A cautious President Lincoln calculates his chances for reelection. A month before the election, Lincoln estimated the electoral votes he and his Democratic rival, George B. McClellan, would win in the presidential election. The Republican column is labeled "Union"; the Democratic party column "Copperhead," or pro-Southern. Lincoln reckoned he would come out ahead by just 120 to 114 electoral votes. However, the results on November 8, 1864, were Lincoln 212, McClellan 21.

*Abraham Africanus I. His Secret Life, ... Mysteries of the White House.* [New York, 1864]. (Huntington Library)

L. Seaman, *What Miscegenation Is! And What We Are to Expect Now that Mr. Lincoln is Re-elected.* [New York, 1864]. (Huntington Library)

Two examples of the racist attacks that Lincoln's Democratic party opponents aimed at him during the 1864 presidential election. As they had done as far back as the Lincoln-Douglas Senate race in 1858, the Democrats appealed to poisonous racial hatred in their attempts to defeat Abraham Lincoln at the polls. They even invented a new word—"miscegenation" (race-mixing)—to warn white Americans what lay ahead under a second Lincoln administration.

opposite: Abraham Lincoln, autograph letter signed to Abram Wakeman, July 25, 1864. (Huntington Library)

Lincoln believed that the Union could not be saved unless he was reelected as president in 1864. In this letter, Lincoln told a supporter that

*"...the present presidential contest will almost certainly be no other than a contest between a Union and a Disunion candidate, disunion certainly following the success of the latter. The issue is a mighty one for all people and all time...."*

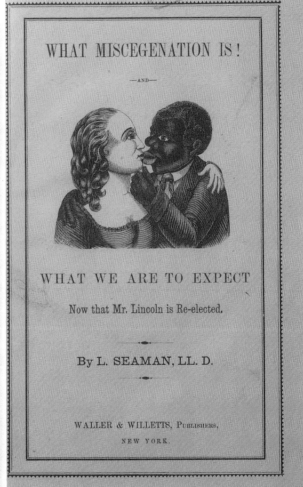

# Executive Mansion,

Washington, July 25, 1864.

Abram Wakeman, Esq

My dear Sir:

I feel that the subject which you pressed upon my attention in our recent conversation is an important one. The men of the South, recently (and perhaps still) at Niagara Falls, tell us distinctly that they _are_ in the confidential employment of the rebellion; and they tell us as distinctly that they are _not_ empowered to offer terms of peace. Does any one doubt that what they _are_ empowered to do, is to assist in selecting and arranging a candidate and a platform for the Chicago Convention? Who could have given them this confidential employment but he who only a week since declared to Jacques and Gilmore that he had no terms of peace but the independence of the South— the dissolution of the Union? Thus the present presidential contest will almost certainly be no other than a contest between a Union and a Disunion candidate, disunion certainly following the success of the latter. The issue is a mighty one for all people and all times; and whoever aids the right, will be appreciated and remembered.

Yours truly

A. Lincoln.

Abraham Lincoln, autograph letter signed to Amanda H. Hall, with passage from his Second Inaugural Address, March 20, 1865. (Illinois State Historical Library)

The Second Inaugural Address is one of Abraham Lincoln's masterpieces, a meditation on history and the divine punishment of an entire nation for the crime of slavery. *"American Slavery"* was a crime, Lincoln said, and as punishment for that crime, God gave *"both North and South, this terrible war."* Lincoln ended his short speech with the soaring invocation of national healing which begins, *"With malice toward none; with charity for all...."*

Executive Mansion.

Washington, March 20. , 1865.

Mrs Amanda H. Hall

Madam

Induced by a letter of yours to your brother, and shown me by him, I send you what follows below.

Respectfully

A. Lincoln

"Fondly do we hope— fervently do we pray— that this mighty scourge of war may speedily pass away. Yet, if God wills, that it continue until all the wealth piled by the bondsman's two hundred and fifty years of unrequited toil shall be sunk, and until every drop of blood drawn with the lash shall be paid by another drawn with the sword, as was said three thousand years ago, so still it must be said; "The judgments of the Lord are true, and righteous altogether."

Abraham Lincoln

opposite: Abraham Lincoln, document signed, February 1, 1865. Souvenir copy of the 13th Amendment to the Constitution, abolishing slavery in the United States. (Huntington Library)

The 13th Amendment abolishing slavery in America forever completed the great work of freedom begun by the Emancipation Proclamation. Victory on the battlefields and in the 1864 elections finally gave Abraham Lincoln a mandate to destroy the *"monstrous injustice"* of slavery. Lincoln helped to push the 13th Amendment through Congress in early 1865. It was ratified by the states in December 1865.

A Duplicate.

## Thirty eighth

Congress of the United States of America, at the second session, begun and held at the City of Washington, on Monday the fifth day of December, one thousand eight hundred and sixty-four.

## A Resolution

Submitting to the legislatures of the several States a proposition to amend the Constitution of the United States.

Resolved by the Senate and House of Representatives of the United States of America in Congress assembled, (two-thirds of both Houses concurring) That the following article be proposed to the legislatures of the several States as an amendment to the Constitution of the United States, which, when ratified by three fourths of said legislatures shall be valid to all intents and purposes, as a part of the said Constitution, namely:

## Article XIII.

Section 1. Neither slavery nor involuntary servitude, except as a punishment for crime whereof the party shall have been duly convicted, shall exist within the United States, or any place subject to their jurisdiction.

Section 2. Congress shall have power to enforce this article by appropriate legislation.

Schuyler Colfax

Speaker of the House of Representatives.

I certify that this Resolution
originated in the Senate

J W Forney
Secretary.

H. Hamlin.
Vice President of the United States
and President of the Senate

Approved February 1, 1865

Abraham Lincoln

# VII

Abraham Lincoln, autograph letter signed to Francis P. Blair, January 18, 1865. (Huntington Library)

In early 1865 Jefferson Davis declared he was ready to negotiate an end to the Civil War to "secure peace to the two countries." Davis's meaning was clear – the Confederacy was an independent nation. Lincoln responded with this letter, pointedly insisting that there was only a single American nation, only one American people, North and South – *"the people of our one common country."*

opposite: Abraham Lincoln, autograph letter signed to John Campbell, April 5, 1865. (Illinois State Historical Library)

President Lincoln's conditions for peace were simple – he demanded the surrender of all Confederate armies, the restoration of the Union and the abolition of slavery. On April 9, 1865, four days after the president wrote this letter, Robert E. Lee surrendered to Grant at Appomattox, winning peace on Lincoln's terms.

*National Inauguration Ball, March 6, 1865.* Dance card with program. (Taper Collection)

(Copy)

Washington. Jan. 18. 1865

F. P. Blair, Esq

Sir:

Your having shown me Mr. Davis' letter to you of the 12th inst. you may say to him that I have constantly been, am now, and shall continue ready to receive any agent whom he, or any other influential person now resisting the national authority may informally send to me with the view of securing peace to the people of our one common country.

Yours &c.

A. Lincoln

Maj. Robert Lincoln

As to peace I have said before, and
now repeat, that three things are indispensable.
1 The restoration of the national authority thr-
oughout all the States.
2. No receding by the Executive of the Uni-
ted States on the slavery question from the
position assumed thereon in the late Annu-
al Message to Congress, and in preceding doc-
uments.
3. No cessation of hostilities short of an end
of the war, and the disbanding of all force
hostile to the government.
That all propositions coming from those now
in hostility to the government, and not in-
consistent with the foregoing, will be respect-
fully considered, and passed upon in a spirit
of sincere liberality.
I now add that it seems useless for me to be
more specific with those who will not say they
are ready for the indispensable terms, even on
conditions to be named by themselves. If there
be any who are ready for those indispensable

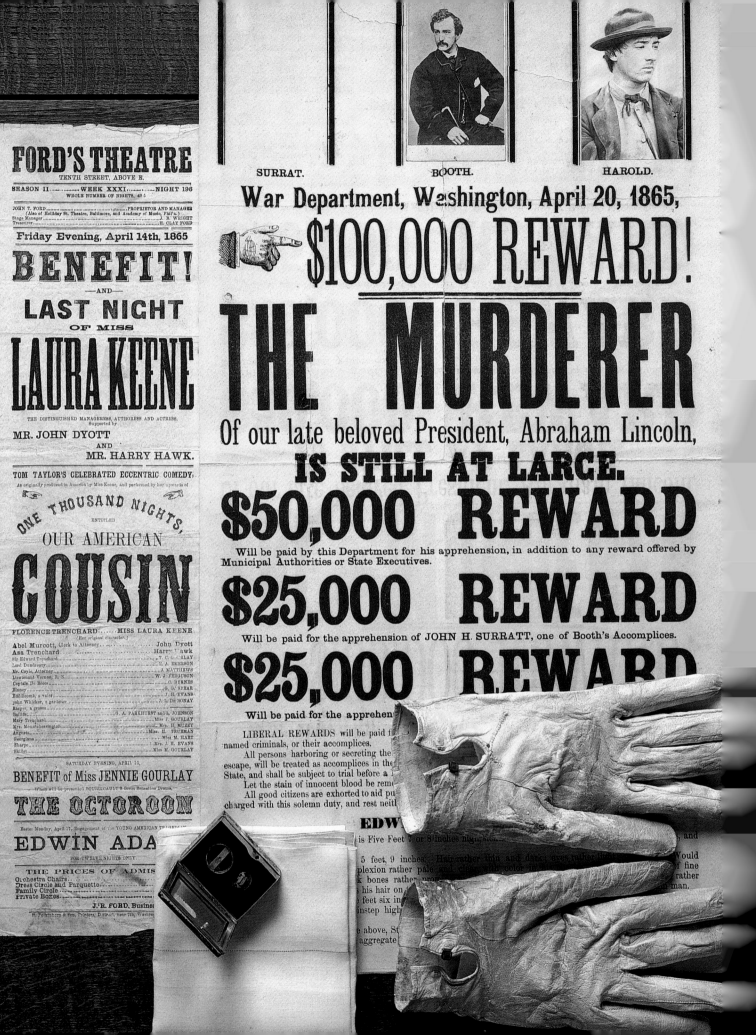

## The Murder of Abraham Lincoln

*"We cannot escape history"*

Ford's Theatre...*Our American Cousin*.... (Taper Collection)
On April 14, 1865, the President and Mary Lincoln went to Ford's Theatre to take in a light comedy. John Wilkes Booth also attended.

[Abraham Lincoln], gloves and handkerchief, carried at Ford's Theatre the night of the assassination. (Taper Collection)

[Abraham Lincoln], shirt stud with "L" monogram, worn at Ford's Theatre the night of the assassination. (Taper Collection)

At about 10:20, Booth slipped into the President's box and shot Lincoln through the head. At 7:22 the next morning, as a cold rain fell across the city of Washington, Abraham Lincoln died.

Edwin M. Stanton, Secretary of War. *$100,000 REWARD THE MURDERER of our late beloved President, Abraham Lincoln IS STILL AT LARGE...Washington, April 20, 1865.* (Huntington Library)
Booth escaped after murdering Abraham Lincoln, but the assassin was tracked down and killed twelve days later. "Tell Mother I died for my country," was the actor's final line.

Abraham Lincoln had been in danger of assassination from the moment he was elected president of a divided country. After the election, the slave states seethed with fear and hatred for Lincoln and his party of "Black Republicans" and race-mixing "amalgamationists." One Southern newspaper wildly predicted that the Potomac River would be "crimsoned in human gore, and Pennsylvania Avenue...paved ten fathoms deep in mangled bodies" before the South would "submit to such humiliation and degradation as the inauguration of Abraham Lincoln." Rumor spoke darkly of gifts of poisoned food sent to the Lincoln home in Springfield, a bomb in a carpetbag, and rewards offered for Lincoln's murder. There appears to have been a genuine plot to kill the president-elect in Baltimore on the way to Washington for his inauguration.

Throughout the Civil War, Lincoln's foes called him tyrant, barbarian, "Abe the Widowmaker," and "King Abraham Africanus I." Jefferson Davis called the Emancipation Proclamation "the most execrable measure in the history of guilty man." To Confederates, Lincoln was a man of real evil, a despot who aimed at nothing less than the destruction of free, white society and the erection in its place of some nightmare African despotism. "What shall we call him?" asked the *Richmond Examiner*, "Coward, assassin, savage, murderer of women and babies? Or shall we consider them all embodied in the word fiend, and call him Lincoln the Fiend."

The Confederate high command initiated, or at least approved, plans to capture Lincoln and carry him south to Richmond as a hostage.

One conspiracy to kidnap the president was organized by a 26-year-old actor named John Wilkes Booth. Booth claimed to be a Confederate secret agent. "A Confederate doing duty upon his own responsibility," is how he signed one letter. Booth changed his plans from kidnapping to murder after listening to the last speech Abraham Lincoln gave. The young actor was outraged when he heard Lincoln say that he favored giving the vote to some African American men. "That means nigger citizenship!" he said, vowing to kill the president.

Lincoln remained fatalistic. He eventually agreed to an escort of armed guards on some of his outings, but believed that nothing could protect him from a determined assassin. Lincoln loved the theater. He continued to go to plays without capable bodyguards. At about ten o'clock on the night of April 14, 1865, John Wilkes Booth fired a single shot into the back of Abraham Lincoln's head as the president sat watching *Our American Cousin* with his wife at Ford's Theatre. Lincoln died early the next morning.

On the morning of April 15 a stunned nation woke to the "black Easter" of 1865. The North, which had been celebrating the victorious end of four years of war with fireworks and five-hundred gun salutes, was suddenly plunged into mourning. Cities were draped in black and more than a million Americans filed past the coffin for a last glimpse of Lincoln's face. The murder of Abraham Lincoln was the final, bloody act that marked the end of America's bloodiest war, a war that Lincoln's election as president had touched off four years before.

Clark Mills, life mask of Abraham Lincoln, plaster, February 11, 1865.
(Taper Collection)

Abraham Lincoln as he appeared two months before his assassination. The sculptor Clark Mills made this cast of Lincoln's face the day before the president's 56th birthday. Four bitter years of war had aged the president, cut deep lines into his face and left him profoundly weary. "Sometimes I think I am the tiredest man on earth," he said.

opposite: Adalbert J. Volck, [Lincoln drafting the Emancipation Proclamation], Baltimore c. 1864, etching.
(Huntington Library)

Racial hatred lay behind much of the malice towards President Lincoln and his party. Many Americans, in the North as well as in the South, believed that Abraham Lincoln was a tyrant who had betrayed the white race by turning the Civil War into a crusade against slavery. In this savage cartoon, Lincoln tramples the Constitution underfoot as he composes the Emancipation Proclamation.

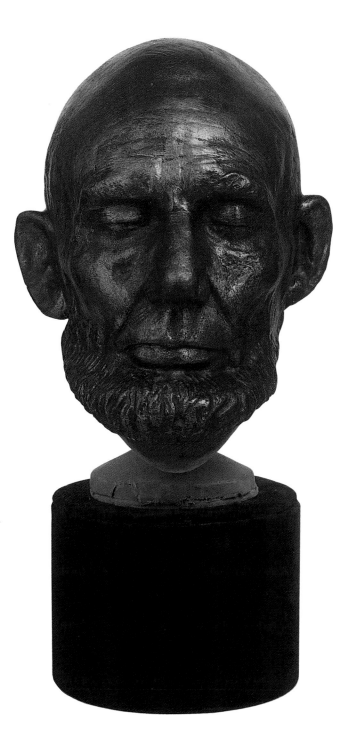

**John Wilkes Booth.**
(Huntington Library)

John Wilkes Booth was one of the most successful actors of his day. Booth believed passionately in the cause of the South. He called slavery a "blessing" and was enraged when he learned that President Lincoln wanted to give some African American men the right to vote. "That means nigger citizenship!" Booth said, vowing to kill Lincoln. Three days later, at Ford's Theatre, the 26-year-old actor made good on his promise.

## Checklist of the Exhibition

"The Last Best Hope of Earth: Abraham Lincoln and the Promise of America" is a library exhibit which relies primarily on documents—original manuscripts and rare printed materials—to tell Lincoln's story. Two authorities are used throughout this checklist for the identification and description of the documents. For manuscripts the source is *The Collected Works of Abraham Lincoln*, edited by Roy C. Basler, 9 vols. and 2 supplements (New Brunswick, N.J., 1953; 1972 and 1990), cited

hereafter as *Collected Works*. For printed material the standard bibliography is Jay Monaghan, compiler, *Lincoln Bibliography, 1839–1939*, 2 volumes (Springfield, Ill., 1945), cited hereafter as Monaghan. The objects, artifacts and memorabilia which supplement the documents in the exhibit do not receive full descriptions. Other supplemental materials which are not original pieces, for instance photographic enlargements and panels of text, are not included in this checklist.

# I

## Frontier Beginnings

Abraham Lincoln, autograph manuscript signed, 1824, "sum book" leaf. (*Collected Works* I:1; Taper Collection)

Abraham Lincoln, partially printed document filled out and signed, 26 September 1832. Illinois militia discharge document, Black Hawk War. (Huntington Library)

Abraham Lincoln, document signed, 19 October 1833. Promissory note to Reuben Radford. (*Collected Works* I:20; Taper Collection)

Abraham Lincoln, autograph letter signed to Blair and Rives, 3 November 1835. (*Collected Works* I:38; Taper Collection)

Abraham Lincoln, autograph document signed, 21 May 1836, survey of Huron, Illinois. (*Collected Works* I: following page 48; Illinois State Historical Library)

Leonard Wells Volk, casts of Lincoln's hands in 1860, bronze. (Huntington Library)

## The Right to Rise

Abraham Lincoln, autograph letter signed to Levi Davis, 19 April 1837. (*Collected Works* I:77–78; Huntington Library)

[Abraham Lincoln], *Attention the People!! A. Lincoln, Esq'r,...one of the Electoral Candidates, will Address the People This Evening!!....Thursday, April 9th, 1840.* (Huntington Library)

Abraham Lincoln, autograph letter signed to Henry E. Drummer, 18 November 1845. (*Collected Works* I:350; Illinois State Historical Library)

Abraham Lincoln, *Speech of Mr. Lincoln, of Illinois, on the reference of the President's Message in the House of Representatives, Wednesday, January 14 [i.e. 12] 1848.* (Washington, 1848.) (Monaghan 4; Huntington Library)

[Abraham Lincoln], "To the Public," Handbill, [5 August 1837] (*Collected Works* I:89–93; Taper Collection)

Abraham Lincoln, autograph document signed, 3 October 1845. Legal bill with "discounted" prices. (Taper Collection)

Illinois, Supreme Court, *Reports of Cases Argued and Determined in the Supreme Court of the State of Illinois*, volume I, (Philadelphia, 1841). Inscribed "Lincoln & Herndon" in the hands of Abraham Lincoln and William H. Herndon. (Taper Collection)

Illinois, Supreme Court, *Reports of Cases Argued and Determined in the Supreme Court of the State of Illinois*, volume IV, (Chicago, 1844). Inscribed "Lincoln & Herndon" in the hands of Abraham Lincoln and William H. Herndon. (Taper Collection)

[Abraham Lincoln], wall clock from the Lincoln-Herndon law office. (Taper Collection)

[Abraham Lincoln], tan stone ink bottle and brown glass ink bottle from the Lincoln-Herndon law office. (Taper Collection)

Abraham Lincoln, autograph document signed, 16 September 1851. Legal brief regarding case of woman accused of "whoring." (Taper Collection)

Abraham Lincoln, autograph document, [February 1854]. Legal brief, Illinois Central Railroad vs. McLean County. (Huntington Library)

[Abraham Lincoln], stock certificate for Lincoln's 6 shares in the Alton and Sangamon Railroad Co., dated 27 August 1852. (Taper Collection)

Abraham Lincoln, autograph letter signed to Hayden Keeling, 3 March 1859. (*Collected Works* III:371; Taper Collection)

[Abraham Lincoln], gold watch key set with diamond. (Illinois State Historical Library)

Abraham Lincoln, autograph letter signed to John M. Brockman, 25 September 1860. (*Collected Works* IV:121; Illinois State Historical Library)

## The Lincoln Family

Abraham Lincoln, autograph letter signed to Mrs. Orville H. Browning, 1 April 1838. (*Collected Works* I:117–19; Huntington Library)

Abraham Lincoln, autograph letter signed to John T. Stuart, 23 January 1841. (*Collected Works* I:229–30; Illinois State Historical Library)

Abraham Lincoln, autograph letter signed to Joshua F. Speed, 5 October 1842. (*Collected Works* I:302–3; Illinois State Historical Library)

Charles Dresser, partially printed document filled out and signed, 4 November 1842. Marriage license of Abraham Lincoln and Mary Todd. (Illinois State Historical Library)

[Abraham Lincoln], door plate from the Lincoln home in Springfield. (Illinois State Historical Library)

[Abraham Lincoln], door key from the Lincoln home. (Illinois State Historical Library)

Abraham Lincoln, autograph letter signed to Mary Todd Lincoln, 16 April 1848. (*Collected Works* I:465–66; Illinois State Historical Library)

Abraham Lincoln, 2 autograph letters signed on a single leaf to Thomas Lincoln and John D. Johnston, 24 December 1848. (*Collected Works* II:15–16; Huntington Library)

Abraham Lincoln, partially printed document filled out and signed, 24 August 1860. Check payable to "Self for Bob." (Taper Collection)

[Lincoln family], three separate cased albumen print photographs Abraham, Mary Todd and Willie Lincoln, with locks of hair. (Taper Collection)

[Mary Lincoln], music box. (Illinois State Historical Library)

[Abraham Lincoln], beaver pelt stovepipe hat. (Taper Collection)

[Abraham Lincoln], pair of reading glasses. (Taper Collection)

[Abraham Lincoln], leather billfold with filing compartments. (Taper Collection)

# II

## Slavery in the Great Republic

Abraham Lincoln, autograph letter signed to Williamson Durley, 3 October 1845. (*Collected Works* I:347–48; Illinois State Historical Library)

*The Anti-Slavery Alphabet,* (Philadelphia: Printed for the Anti-Slavery Fair, 1847). (Huntington Library)

Abraham Lincoln, autograph letter signed to Usher F. Linder, 22 March 1848. (*Collected Works* I:457–58; Illinois State Historical Library)

Abraham Lincoln, autograph document signed, [1 August 1858?]. Definition of democracy. (*Collected Works* II:532; Illinois State Historical Library)

Abraham Lincoln, autograph document, [1 October 1858?]. The "proslavery theology" of Dr. Frederick A. Ross. (*Collected Works* III:204–205; Illinois State Historical Library)

Frederick A. Ross, *Slavery Ordained of God,* (Philadelphia, 1857). (Huntington Library)

Samuel Haycraft, *Commissioner's Sale of Valuable Negroes...Three Likely Negroes, Consisting of two valuable women and one boy. Lucy, Ann and Peter....October 10th, 1856* (Hardin County, Kentucky, 1856). Broadside. (Taper Collection)

Thom[a]s A. Morgan, *Marshal's Sale... On Monday, Dec. 12, 1864....The Slaves Ellen, Jim, Margaret, John, Ann, Alice, George, Hentz, and another slave, name unknown....*(Louisville, Kentucky, 1864). (Taper Collection)

## Back in the Political Arena

Abraham Lincoln, autograph letter signed to Jonathan Y. Scammon, 10 November 1854. (*Collected Works Supplement* I:25; Illinois State Historical Library)

Abraham Lincoln, autograph letter signed to Jesse Olds Norton, 16 February 1855. (*Collected Works Supplement* II:9–11; Taper Collection)

Abraham Lincoln, autograph letter signed to Owen Lovejoy, 11 August 1855. (*Collected Works* II:316–17; Huntington Library)

Abraham Lincoln, autograph letter signed to Lyman Trumbull, 7 June 1856. (*Collected Works* II:342–43; Huntington Library)

Abraham Lincoln, autograph letter signed to Lyman Trumbull, 30 November 1857. (*Collected Works* II:427–28; Huntington Library)

## The Lincoln-Douglas Debates

Abraham Lincoln, autograph letter signed to Lyman Trumbull, 23 June 1858. (*Collected Works* II:471–72; Huntington Library)

*Grand Rally of the Lincoln Men of Old Tazewell! We Honor the Honest Abraham Lincoln. At Pekin, on Tuesday, October 5th, 1858....*(Pekin, Illinois, 1858). (Illinois State Historical Library)

Abraham Lincoln, autograph letter signed to John L. Scripps, 23 June 1858. (*Collected Works* II:471; Illinois State Historical Library)

Abraham Lincoln, autograph document, 15 September 1858. Notes for the debate at Jonesboro. (*Collected Works* III:101 and *Supplement* I:33; Illinois State Historical Library)

Abraham Lincoln, autograph letter signed to James N. Brown written in small pocket notebook, 18 October 1858. (*Collected Works* III:327–28; Huntington Library)

Leonard Wells Volk, life mask in bronze of Stephen A. Douglas, c. 1858. (Taper Collection)

Leonard Wells Volk, life mask in bronze of Abraham Lincoln in 1860. (Taper Collection)

Abraham Lincoln, autograph letter signed to Henry Asbury, 19 November 1858. (*Collected Works* III:339; Illinois State Historical Library)

Abraham Lincoln and Stephen A. Douglas, *Political Debates between Hon. Abraham Lincoln and Hon. Stephen A. Douglas in the celebrated campaign of 1858, in Illinois....*Inscribed copy (Columbus, Ohio, 1860). (Monaghan 69; Taper Collection)

# III

## Nominated for the Presidency

Abraham Lincoln, autograph letter signed to Thomas J. Pickett, 16 April 1859. (*Collected Works* III:377; Illinois State Historical Library)

Abraham Lincoln, letter signed to Mark W. Delahay, 14 May 1859. (*Collected Works* III:378 Illinois State Historical Library)

Abraham Lincoln, autograph document, 16 September 1859. Notes for speech at Columbus, Ohio. (*Collected Works Supplement,* 1:41–43; Illinois State Historical Library)

*Abraham Lincoln,* the American Bank Note Co., engraved portrait signed in pencil, [January 1861], based on Brady photograph of 27 February 1860. (Taper Collection)

Abraham Lincoln, *The Address of the Hon. Abraham Lincoln, in Vindication of the Policy of the Framers of the Constitution and the Principles of the Republican Party, Delivered at the Cooper Institute, 27th February 1860,...* (New York, 1860). (Monaghan 68; Huntington Library)

Abraham Lincoln, autograph letter signed to Richard M. Corwine, 6 April 1860. (*Collected Works* IV:36; Illinois State Historical Library)

Abraham Lincoln, autograph letter signed to Lyman Trumbull, 29 April 1860. (*Collected Works* IV:45–46; Huntington Library)

*The Life, Speeches, and Public Services of Abram Lincoln, Together with a Sketch of the Life of Hannibal Hamlin. Republican candidates for the Offices of President and Vice-President of the United States,* (New York, 1860). (Monaghan 92; Huntington Library)

Ribbon with pinned-on paper photograph of Abraham Lincoln worn by Lincoln delegation to Chicago Convention. (Illinois State Historical Library)

## The Republican Candidate, 1860

Abraham Lincoln, autograph letter signed to Lyman Trumbull, 1 May 1860. (*Collected Works* IV:47; Huntington Library)

Currier & Ives, *Honest Abe taking them on the Half-shell.* Lithograph, New York, 1860. (Huntington Library)

B. Cooley, portrait of Stephen A. Douglas, 1867. (Taper Collection)

Alexander Hesler, albumen print photograph signed by Abraham Lincoln, from lost original negative made 3 June 1860. (Taper Collection)

Abraham Lincoln, autograph letter signed to Joshua R. Giddings, 26 June 1860. (*Collected Works* IV:80–81; Taper Collection)

Abraham Lincoln, autograph letter signed to Samuel Haycraft, 4 June 1860. (*Collected Works* VI:69–70; Huntington Library)

Abraham Lincoln, autograph letter signed to George T. M. Davis, 27 October 1860. (*Collected Works* IV:132–33; Illinois State Historical Library)

*Life of Abram Lincoln. Price One Cent.* (New York, 1860). (Monaghan 49; Huntington Library)

[William Dean Howells], *Life and Speeches of Abraham Lincoln and Hannibal Hamlin* (Columbus, Ohio, 1860). Abraham Lincoln's copy of this campaign biography with manuscript corrections in Lincoln's hand. (Monaghan 44; Illinois State Historical Library)

Uncle Abe's *Republican Songster For "Uncle Abe's Choir."* (San Francisco, 1860). (Monaghan 84; Illinois State Historical Library)

*Wide-Awake Pictorial. For November 1860. Honest Old Abe Marching Forth to the White House.* (n.p., n.d.) (Monaghan 90; Illinois State Historical Library)

"Lincoln and Hamlin" Wide-Awake banner. (Illinois State Historical Library)

"Wide-Awake" blouse and skirt, blue oilcloth. (Illinois State Historical Library)

Lincoln-Hamlin "Union 1860" paper lantern. (Taper Collection)

Lincoln-Hamlin campaign flag. (Taper Collection)

"Wide-Awake" torch in the shape of an American eagle. (Illinois State Historical Library)

"Wide-Awake" torch on pole. (Taper Collection)

[Abraham Lincoln, 1860 campaign]: fragment of fence rail split by Abraham Lincoln. (Illinois State Historical Library)

# IV

## The Secession Crisis

Abraham Lincoln, autograph draft, 20 November 1860. Passage for speech of Lyman Trumbull. (*Collected Works* IV:141–42; Illinois State Historical Library)

Abraham Lincoln, autograph letter signed to Lyman Trumbull, 10 December 1860. (*Collected Works* IV:149–50; Huntington Library)

Abraham Lincoln, autograph letter signed to Alexander H. Stephens, 22 December 1860. (*Collected Works* IV:160–61; Huntington Library)

Abraham Lincoln, autograph letter signed to Lyman Trumbull, 24 December 1860. (*Collected Works* IV:162, Huntington Library)

*"THE UNION IS DISSOLVED!" Charleston Mercury* Extra and Ordinance of Secession, 20 December 1860. (Huntington Library)

Mason Locke Weems, *Life of George Washington....*(Philadelphia, 1809). (Huntington Library)

Abraham Lincoln, second edition of draft of *First Inaugural Address,* before 12 February 1861; with autograph note signed by Orville H. Browning. (*Collected Works* IV:249 ff; Huntington Library)

Wooden inkwell used by Abraham Lincoln to write First Inaugural Address. (Illinois State Historical Library)

*Union Ball 1861.* (invitation to First Inaugural ball, 4 March 1861). (Illinois State Historical Library)

Abraham Lincoln, letter signed to Edward Bates, 15 March 1861. (*Collected Works* IV:284–85; Illinois State Historical Library)

Abraham Lincoln, autograph letter signed to Gideon Welles, 29 March 1861. (*Collected Works* IV:301; Huntington Library)

## Commander in Chief

Abraham Lincoln, document, 19 April 1861. Proclamation of blockade of Confederacy. (*Collected Works* IV:338–39; Taper Collection)

Abraham Lincoln, autograph note signed, 25 October 1861. (*Collected Works* V:4; Taper Collection)

Abraham Lincoln, autograph note signed, 20 August 1863. (Taper Collection)

Abraham Lincoln, autograph letter signed to George B. McClellan, 15 September 1862. (*Collected Works* V:426; Illinois State Historical Library)

Abraham Lincoln, autograph letter signed to George B. McClellan, 24 October 1862. (*Collected Works* V:474; Illinois State Historical Library)

Abraham Lincoln, autograph letter signed to George B. McClellan, 27 October 1862. (*Collected Works* V:479; Illinois State Historical Library)

Abraham Lincoln, autograph letter signed to Henry Halleck, 5 November 1862. (*Collected Works* V:485; Illinois State Historical Library)

Abraham Lincoln, autograph note signed, 28 May 1864. (Taper Collection)

Abraham Lincoln, autograph letter signed to Ulysses S. Grant, 30 April 1864. (*Collected Works* VII:324–25; Huntington Library)

John Rogers, "The Council of War," [1868]. Plaster, Robert Todd Lincoln's copy. (Taper Collection)

# V

## War for the Union: 1861–1862

[Adalbert J. Volck], [*The Baltimore Riot of April 19, 1861*]. Etching [Baltimore, c. 1861]. (Huntington Library)

Abraham Lincoln, autograph letter signed to Beriah Maggofin, 24 August 1861. (*Collected Works* IV:497; Illinois State Historical Library)

Abraham Lincoln, letter signed to Orville H. Browning, 22 September 1861. (*Collected Works* IV:531; Illinois State Historical Library)

Abraham Lincoln, autograph document, [26? November 1861]. Draft of a bill for a program of gradual, compensated emancipation in Delaware. (*Collected Works* IV:29–31; Huntington Library)

Leonard Wells Volk, right hand of Abraham Lincoln. Marble, Rome, 1869. (Taper Collection)

[Abraham Lincoln], riding gloves of Abraham Lincoln. (Illinois State Historical Library)

[Abraham Lincoln], carriage robe of Abraham Lincoln. (Illinois State Historical Library)

[Abraham Lincoln], American flag flown over the Lincoln White House. (Huntington Library)

## War for Union and Freedom: 1862–1865

Abraham Lincoln, printed document signed. The Emancipation Proclamation, lithograph souvenir printing, (San Francisco, 1864). (*Collected Works*, VI:28–31; Taper Collection)

[Abraham Lincoln], White House pen used by Lincoln. (Illinois State Historical Library)

Abraham Lincoln, autograph letter signed to Nathaniel Banks, 29 March 1863. (*Collected Works* VI:154; Huntington Library)

Abraham Lincoln, autograph letter signed to David Hunter, 1 April 1863. (*Collected Works* VI:158; Huntington Library)

Abraham Lincoln, letter signed to Stephen A. Hurlbut, 31 July 1863. (*Collected Works* VI:358–59; Illinois State Historical Library)

Abraham Lincoln, autograph letter signed to Nathaniel Banks, 5 August 1863. (*Collected Works* VI:364–66; Illinois State Historical Library)

Abraham Lincoln, autograph manuscript, 19 November 1863. The Gettysburg Address, the Edward Everett copy. (*Collected Works* VII:21–22; Illinois State Historical Library)

Abraham Lincoln, autograph letter signed to Frederick Steele, 20 January 1864. (*Collected Works* VII:141–42; Huntington Library)

Abraham Lincoln, autograph letter signed to Daniel Sickles, 15 February 1864. (*Collected Works* VII:185; Taper Collection)

Abraham Lincoln, autograph quotation signed, 22 March 1864. "I never knew a man who wished to be himself a slave." (*Collected Works* VII:260–61; Huntington Library)

# VI

## Life in the Lincoln White House

William Makepeace Thayer, *The Pioneer Boy, and how he became President....*(Boston, 1863). (Monaghan 249; Huntington Library)

Abraham Lincoln, autograph note signed to John A. Dahlgren, 14 October 1862. (*Collected Works* V:463; Illinois State Historical Library)

Tad Lincoln's brass scale-model Dahlgren Boat Howitzer. (Illinois State Historical Library)

Abraham Lincoln, autograph letter signed to Benjamin B. French, 3 August 1863. (Taper Collection)

Abraham Lincoln, autograph telegram signed to Mary Todd Lincoln, 24 September 1863. (*Collected Works* VI:478; Illinois State Historical Library)

Abraham Lincoln, autograph note signed to J. E. Allen, 7 April 1864. (*Collected Works Supplement* I:235; Taper Collection)

Abraham Lincoln, signature in salesman's order book for forthcoming edition of Joel Tyler Headley, *The Great Rebellion: a History of the Civil War in the United States....*(Hartford, Conn., 1864). (Taper Collection)

Abraham Lincoln, autograph letter signed to Mary Todd Lincoln, 1864. (Taper Collection)

[Abraham Lincoln], engraved White House invitation, 17 October 1861. (Taper Collection)

[Abraham Lincoln], engraved White House invitation, 1 March 1864. (Taper Collection)

Abraham Lincoln, signed *carte-de-visite* photograph, made by Alexander Gardner 9 August 1863. (Taper Collection)

[Mary Lincoln], William D. Haley, editor, *Philp's Washington Described. A Complete View of the American Capital....* (New York, 1861). Mary Lincoln's copy with "Mrs. A. Lincoln" stamped in gold on cover. (Taper Collection)

[Abraham Lincoln], handkerchief, monogrammed ("A") by Mary Lincoln. (Taper Collection)

[Mary Lincoln], diamond ring. (Illinois State Historical Library)

[Mary Lincoln], coral necklace and earrings. (Illinois State Historical Library)

[Mary Lincoln], ivory calendar/ notebook. (Illinois State Historical Library)

[Mary Lincoln], buff tureen and eight *pots de creme* from the White House china service. (Taper Collection)

[Mary Lincoln], chamber pot from the White House china service. (Taper Collection)

[Mary Lincoln], assorted crystal from the White House. (Taper Collection)

[Mary Lincoln], pink-border china tureen with "ML" monogram from the White House china service. (Taper Collection)

[Mary Lincoln], ivory letter opener. (Taper Collection)

[Mary Lincoln], tea napkin and handkerchief with "ML" monogram. (Taper Collection)

[Mary Lincoln], pair of white gloves. (Taper Collection)

[Mary Lincoln], leather letter box. (Taper Collection)

[Mary Lincoln], 12 silver soup spoons with "ML" monogram. (Taper Collection)

[Mary Lincoln], linen nightcap. (Taper Collection)

Lily Tolpo, bronze bust of Mary Lincoln. (Taper Collection)

# VII

## Reelected in 1864

Abraham Lincoln, document signed, 10 August 1863. Draft call for New York volunteers. (Taper Collection)

Abraham Lincoln, letter signed to James C. Conkling, 26 August 1863. (*Collected Works* VI:406–10; Illinois State Historical Library)

Abraham Lincoln, autograph letter signed to Abram Wakeman, 25 July 1864. (*Collected Works* VII:461; Huntington Library)

Abraham Lincoln, document signed, 23 August 1864. The "blind memorandum," Gideon Welles' copy. (*Collected Works* VII:514–15; Huntington Library)

Abraham Lincoln, autograph document, 13 October 1864. Estimated electoral vote. (*Collected Works* VIII:46; Huntington Library)

Abraham Lincoln, autograph document, [c. 1 December 1864]. Tabulation and comparison of election returns—1860 and 1864. (*Collected Works* VIII:128–30; Illinois State Historical Library)

L. Seamans, *What Miscegenation Is! And What We Are to Expect Now that Mr. Lincoln is Re-elected.* (New York, 1864). (Monaghan 350; Huntington Library)

*Abraham Africanus I. His Secret Life,... Mysteries of the White House.* New York, [1864]. (Monaghan 267; Huntington Library)

*The Lincoln and Johnson Union Campaign Songster.* Philadelphia, [1864]. (Monaghan 322; Illinois Historical Library)

*National Union Ticket,* 1864 Lincoln and Johnson campaign poster, color lithograph, (Philadelphia, 1864). (Huntington Library)

[Abraham Lincoln], *National Inauguration Ball, March 6, 1865.* Dance card with program. (Taper Collection)

## Victory

Abraham Lincoln, *Inaugural Address. March 4, 1865.* [Washington, D.C., 1865]. First printing of Lincoln's Second Inaugural Address. (Monaghan 600; Huntington Library)

Abraham Lincoln, autograph letter signed to Mrs. Amanda H. Hall, 20 March 1865. (*Collected Works* VIII:367; Illinois State Historical Library)

Abraham Lincoln, document signed, 1 February 1865. The abolition of slavery: souvenir copy of Congressional resolution submitting the 13th Amendment to the states for ratification. (*Collected Works* VIII:253–54; Huntington Library)

Abraham Lincoln, autograph letter signed to Francis P. Blair, 18 January 1865. (*Collected Works* VIII:220–21; Huntington Library)

Abraham Lincoln, autograph letter to John Campbell, 5 April 1865. (*Collected Works* VIII:386–387; Illinois State Historical Library)

# VIII

## The Assassination

[Adalbert J. Volck], [*Lincoln drafting the Emancipation Proclamation*], etching [Baltimore, c. 1864]. (Huntington Library)

Ford's Theatre...Friday Evening, April 14th, 1865....Last Night of Miss Laura Keene....*Our American Cousin....*Playbill. (Taper Collection)

[Abraham Lincoln], gloves, worn at Ford's Theatre the night of the assassination. (Taper Collection)

[Abraham Lincoln], handkerchief, carried at Ford's Theatre the night of the assassination. (Taper Collection)

Abraham Lincoln, shirt stud with "L" monogram, worn at Ford's Theatre the night of the assassination. (Taper Collection)

Ford's Theatre chair. (Taper Collection)

Edwin M. Stanton, Secretary of War. *$100,000 REWARD THE MURDERER of our late beloved President, Abraham Lincoln IS STILL AT LARGE...Washington, April 20,1865.* (Huntington Library)

Clark Mills life mask of Abraham Lincoln, 11 February 1865, plaster. (Taper Collection)

James Burns, painting, *Lincoln's Last Moments,*1866. (Taper Collection)

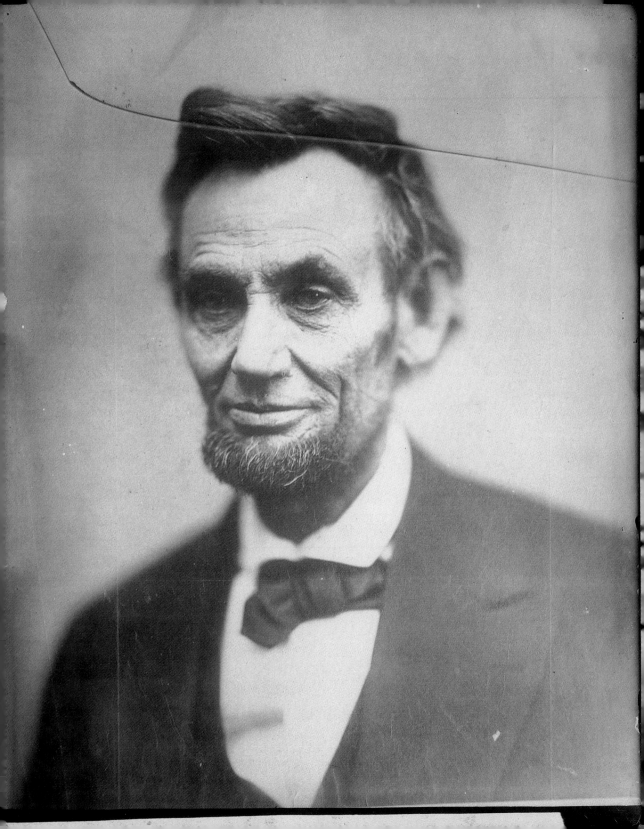

# Abraham Lincoln Bibliography

One of the last photographs of Abraham Lincoln from life, taken by Alexander Gardner in the spring of 1865. (Huntington Library)

## Primary Sources:

Abraham Lincoln, *The Collected Works of Abraham Lincoln,* edited by Roy P. Basler, Marion Dolores Pratt and Lloyd A Dunlap, asst. eds., 9 vols. plus two supplements, New Brunswick, N.J.: Rutgers University Press, 1953; 1972 and 1990.

David C. Mearns, *The Lincoln Papers: The Story of the Collection with Selections to July 4, 1861,* 2 vols., Garden City, N.Y.: Doubleday, 1948; Kraus Reprint Co., 1969.

Emanuel Hertz, *The Hidden Lincoln: From the Letters and Papers of William H. Herndon,* N.Y.: Viking, 1938.

## Reference:

Paul M. Angle, *A Shelf of Lincoln Books: A Critical, Selective Bibliography of Lincolniana,* New Brunswick, N.J.: Rutgers University Press, 1946.

Earl Schenck Miers, ed., *Lincoln Day by Day,* 3 vols., Washington, D.C.: Lincoln Sesquicentennial Commission, 1960.

Mark E. Neely, Jr. *Abraham Lincoln Encyclopedia,* N.Y.: McGraw-Hill, 1982.

Archer Shaw, *The Lincoln Encyclopedia,* N.Y.: Macmillan, 1950.

## Anthologies:

Don E. Fehrenbacher, ed., *Lincoln: Speeches and Writings,* 2 vols., N.Y.: Library of America, 1989.

Mario Cuomo and Harold Holzer, compilers, *Lincoln on Democracy,* N.Y.: HarperCollins Publishers, 1990.

## Biographies:

William H. Herndon and Jesse W. Weik, *Herndon's Life of Lincoln,* Paul M. Angle, ed., N.Y.: Da Capo, 1983.

Benjamin P. Thomas, *Abraham Lincoln,* N.Y.: Alfred A. Knopf, 1952.

John G. Nicolay and John Hay, *Abraham Lincoln: A History,* 10 vols., N.Y.: Century Co., 1890.

James Garfield Randall and Richard M. Current, *Lincoln the President,* 4 vols., N.Y.: Dodd, Mead & Co., 1945–55.

Stephen B. Oates, *With Malice Toward None,* N.Y.: Harper & Row, 1977.

## Youth and Early Adulthood:

Louis A. Warren, *Lincoln's Parentage and Childhood,* N.Y.: The Century Company, 1926.

Louis A. Warren, *Lincoln's Youth: Indiana Years,* Indianapolis: Indiana Historical Society, rpt. 1991.

Benjamin P. Thomas, *Lincoln's New Salem,* Carbondale. Ill.: Southern Illinois University Press rpt. 1987.

## Life to 1860:

Paul M. Angle, *"Here I Have Lived": A History of Lincoln's Springfield,* Chicago: Abraham Lincoln Book Shop, rpt. 1971.

Paul Simon, *Lincoln's Preparation for Greatness,* Urbana, Ill.: University of Illinois Press, rpt. 1971.

Don E. Fehrenbacher, *Prelude to Greatness: Lincoln in the 1850's,* Stanford, Calif.: Stanford University Press, 1962.

John J. Duff, *A. Lincoln: Prairie Lawyer,* N.Y.: Rinehart & Co., 1960.

## Election and Presidency:

Reinhard H. Luthin, *The First Lincoln Campaign,* Cambridge, Mass.: Harvard University Press, 1944.

David M. Potter, *Lincoln and His Party in the Secession Crisis,* N.Y.: AMS Press, rpt. 1979.

T. Harry Williams, *Lincoln and His Generals,* N.Y.: Alfred A. Knopf, 1952.

Mark E. Neely, Jr., *The Fate of Liberty: Abraham Lincoln and Civil Liberties,* N.Y.: Oxford University Press, 1991.

LaWanda Cox, *Lincoln and Black Freedom,* Columbia, S.C.: University of South Carolina Press, 1981.

## Civil War and Reconstruction:

James M. McPherson, *Battle Cry of Freedom,* N.Y.: Oxford University Press, 1988.

James M. McPherson, *Abraham Lincoln and the Second American Revolution,* N.Y.: Oxford University Press, 1990.

Phillip S. Pauldan, *"A People's Contest": The Union and the Civil War 1861–65,* N.Y.: Harper & Row, 1987.

Eric Foner, *Reconstruction: America's Unfinished Revolution, 1863–1877,* N.Y.: Harper & Row, 1988.

## The Lincoln Family:

Ruth Painter Randall, *Lincoln's Sons,* Boston: Little Brown and Company, 1955.

Ruth Painter Randall, *Mary Lincoln: Biography of A Marriage,* Boston: Little Brown and Company, 1953.

Jean B. Baker, *Mary Todd Lincoln: A Biography,* N.Y.: W. W. Norton & Co., 1987.

Justin and Linda Turner, *Mary Todd Lincoln: Her Life and Letters,* N.Y.: Alfred A. Knopf, 1972.

Mark E. Neely, Jr., and R. Gerald McMurtry, *The Insanity File: The Case of Mary Todd Lincoln,* Carbondale, Ill.: Southern Illinois University Press, 1986.

Mark E. Neely, Jr., and Harold Holzer, *The Lincoln Family Album,* Garden City, N.Y.: Doubleday, 1990.

## Assassination and Funeral:

William Hanchett, *The Lincoln Murder Conspiracies,* Urbana, Ill.: University of Illinois Press, 1983.

Dorothy and Philip Kunhardt, *Twenty Days,* N.Y.: Harper and Row, 1965.

The design and typographic
format of this catalogue are
by Ken & Denis Parkhurst of
Los Angeles. Composed by
Central Typesetting Com-
pany, Los Angeles, in Janson
with Caslon 540 and Bauer
Bodoni phototypes. Printing
on *Remarque*, a recycled
coated paper, was contrib-
uted by Nestlé USA.